Explorations of the Seed Vault

This colouring-book lets you explore some of the seeds found in the Svalbard Global Seed Vault. The book comes out of an experimental design-project called 'Explorations of the Seed Vault' - about using design to interpret and communicate the digital database of the Svalbard Global Seed Vault. The project was created in 2017 by **Einar Sneve Martinussen** and **Jørn Knutsen** from the Oslo School of Architecture and Design..

The Svalbard Global Seed Vault is located underground in the permafrost on the Norwegian island of Spitsbergen in the Svalbard archipelago. This is the world's largest secure seed storage facility and holds seeds from more than 5.500 species of crop plants. The Seed Vault is a part of an important global collaboration for preserving the biodiversity and resilience of crops for the future. The Svalbard Global Seed Vault was opened in 2008 and is managed through an agreement between the Norwegian government, the Crop Trust and the Nordic Genetic Resource Centre (NordGen).

The seeds in the Svalbard Seed Vault are back-up samples of seeds from seed banks all over the world. In case of unforeseen events, or regional or global crisis, the Seed Vault can act as a safeguard against the loss of seeds and genetic diversity. About three times a year new seed samples are deposited in the Seed Vault. Currently, in June 2017, the vault holds 597.238.873 seeds.

Information about the seed samples in the Vault are accessible online through a digital database hosted by NordGen. In 2017, designers Einar Sneve Martinussen and Jørn Knutsen explored how this data could be visualised and communicated as a part of a residency at the Centre for Contemporary Art in Prague for the exhibition 'Big Bang Data'. This colouring-book is one of the outputs of this proect. In this book information from the database have been used to identify and describe the most, and least, common species found in the Seed Vault. This quite abstract information have then been turned into detailed illustrations in the style of a colouring-book. Filling in a colouring-book makes you pay to extra close attention to details. With this colouring-book we want to pay extra close attention to the diversity and beauty of the seeds that the Svalbard Global Seed Vault was built to protect.

More about the project at: *medium.com/explorations-of-the-seed-vault*

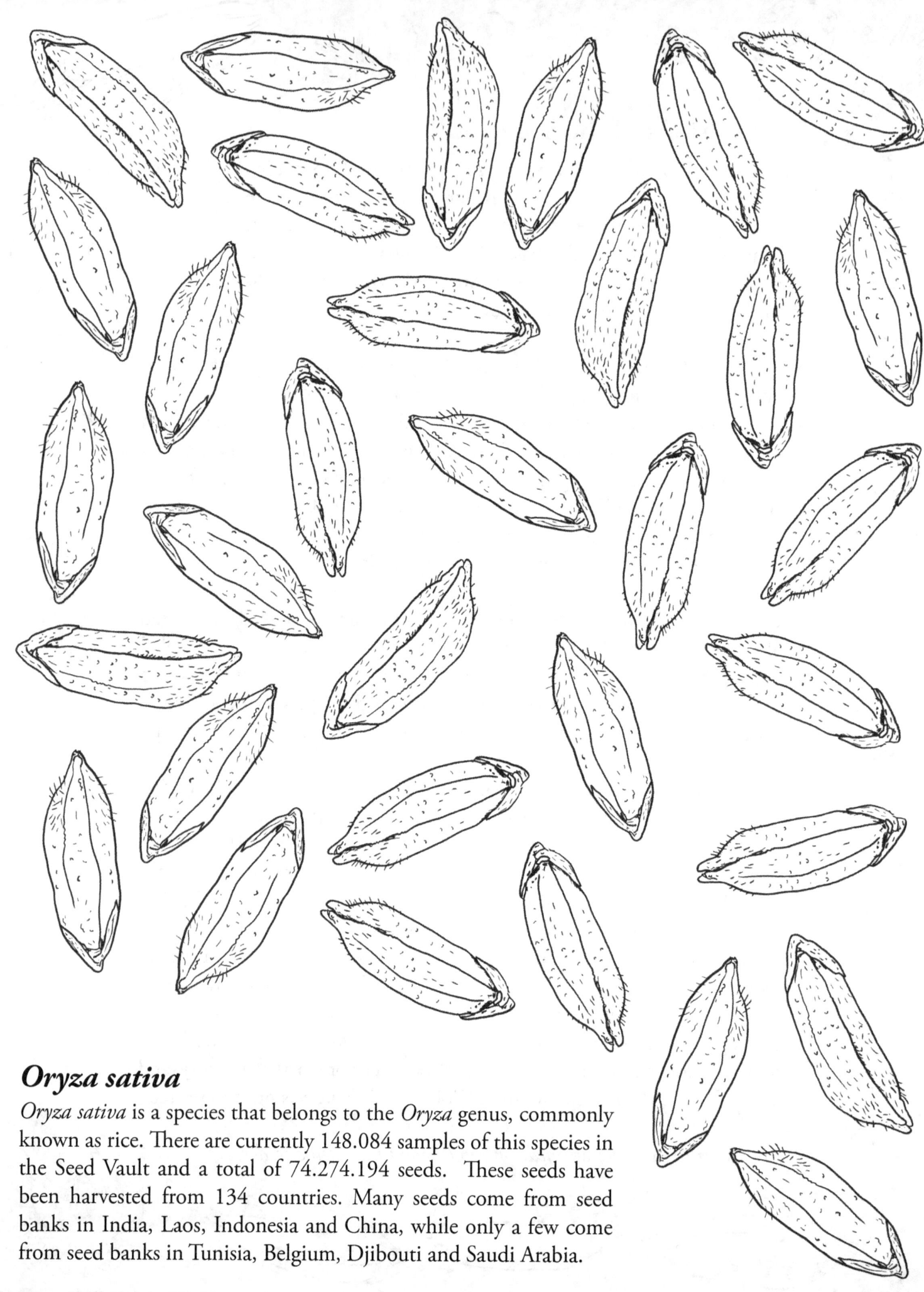

Oryza sativa

Oryza sativa is a species that belongs to the *Oryza* genus, commonly known as rice. There are currently 148.084 samples of this species in the Seed Vault and a total of 74.274.194 seeds. These seeds have been harvested from 134 countries. Many seeds come from seed banks in India, Laos, Indonesia and China, while only a few come from seed banks in Tunisia, Belgium, Djibouti and Saudi Arabia.

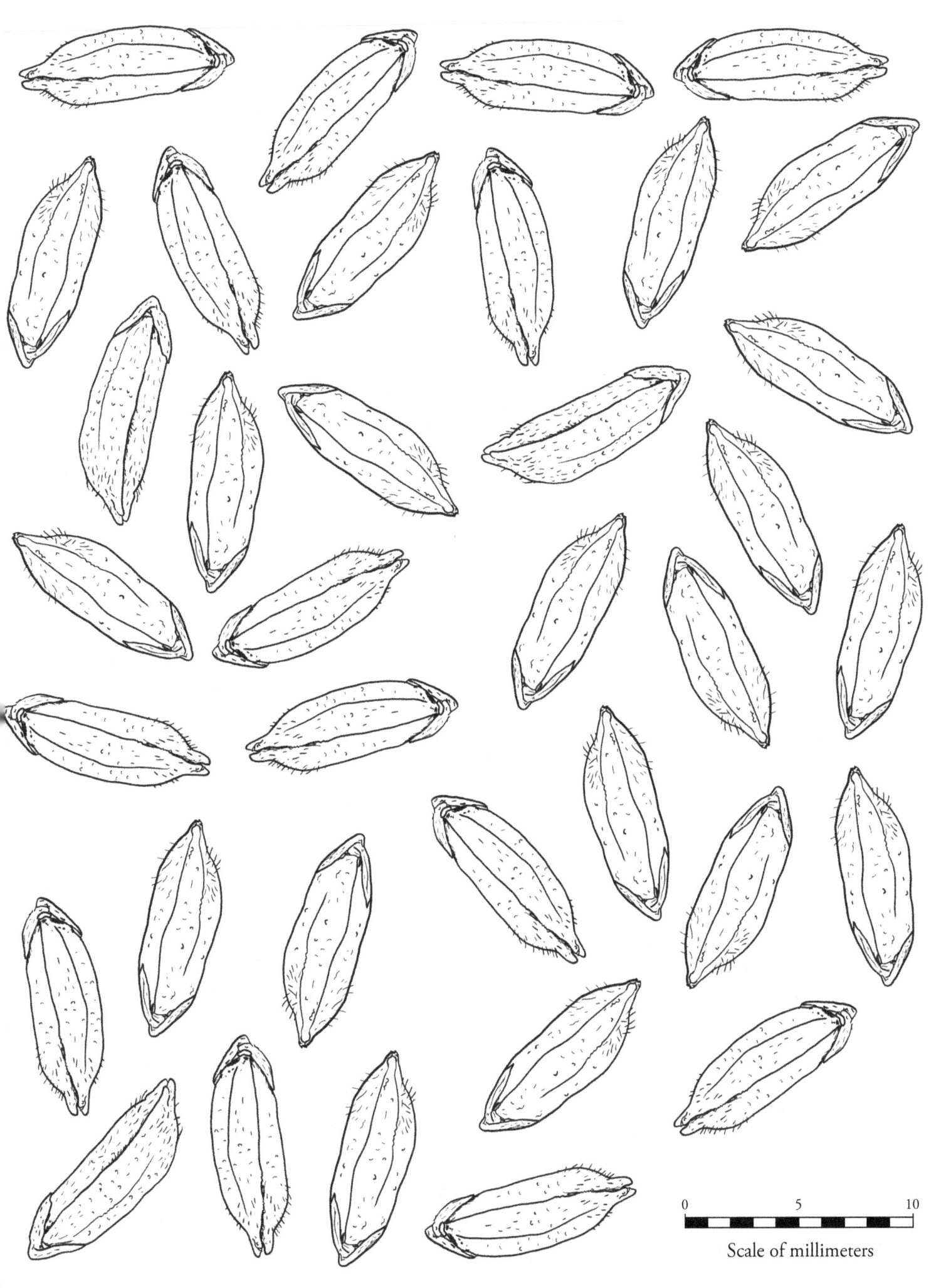

Scale of millimeters

Triticum aestivum

Triticum aestivum is a species that belongs to the *Triticum* genus, commonly known as wheat. There are currently 125.595 samples of this species in the Seed Vault and a total of 44.036.395 seeds. These seeds have been harvested from 124 countries. Many seeds come from seed banks in Mexico, while only a few come from seed banks in Rwanda, Thailand and Honduras.

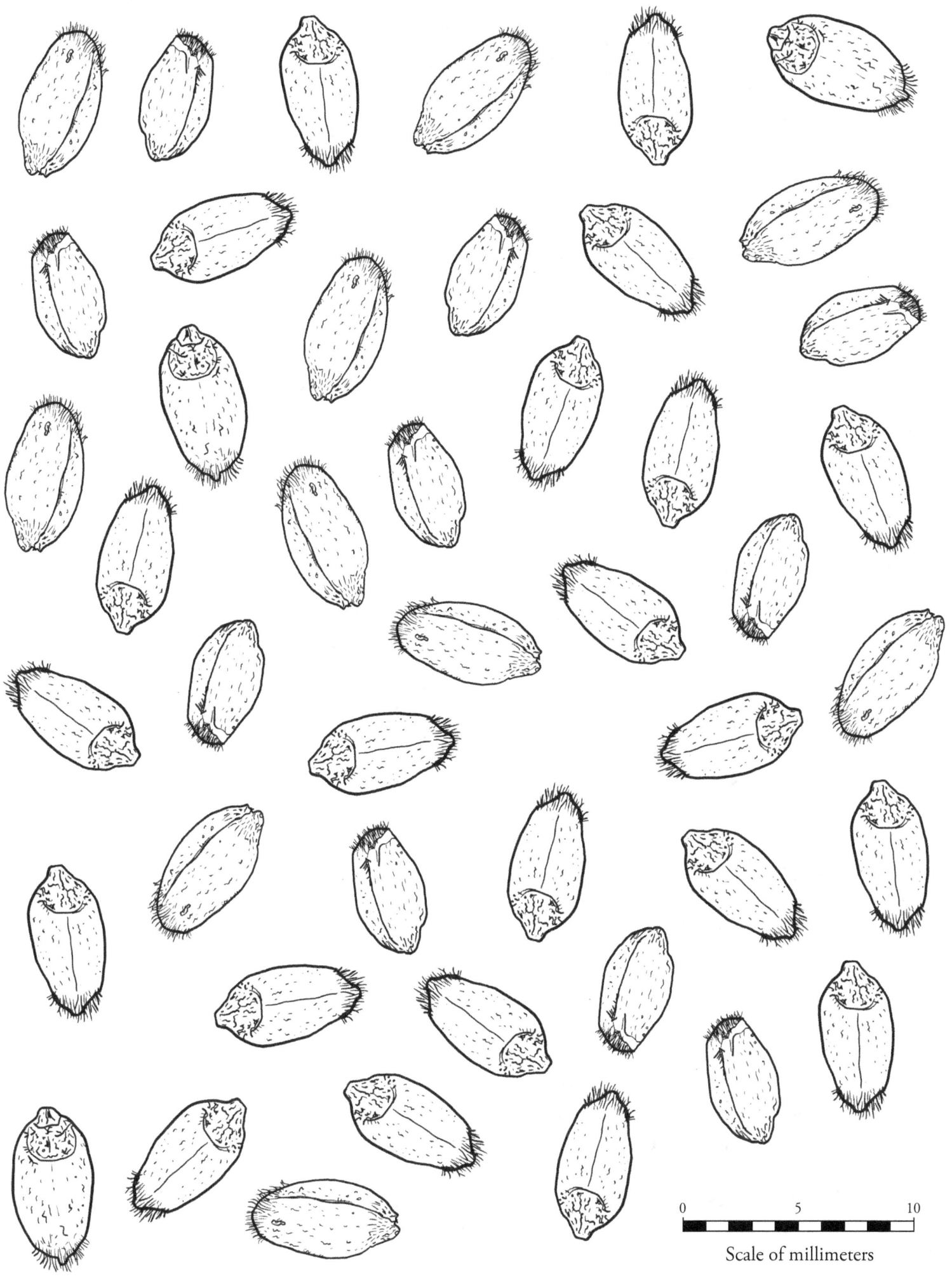

Scale of millimeters

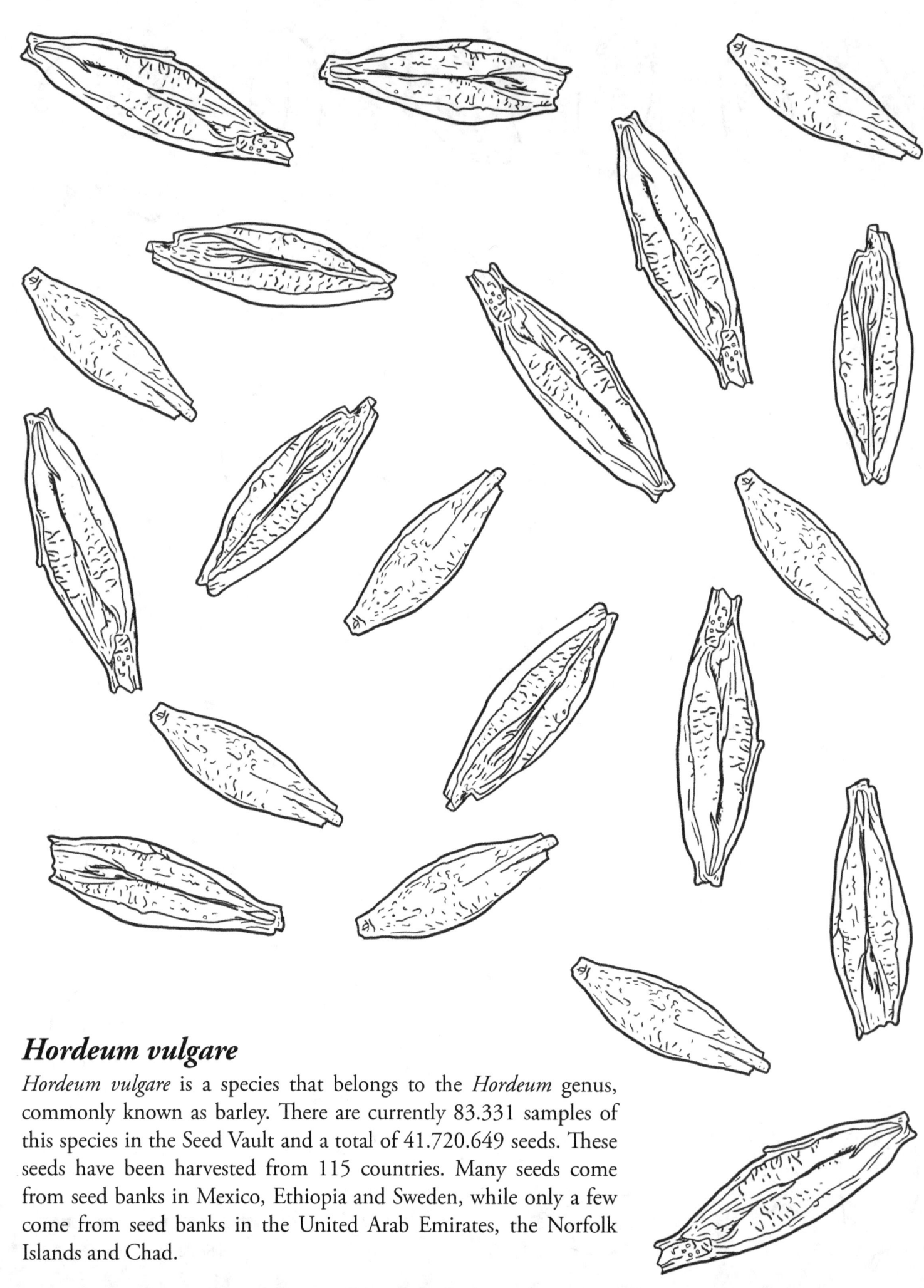

Hordeum vulgare

Hordeum vulgare is a species that belongs to the *Hordeum* genus, commonly known as barley. There are currently 83.331 samples of this species in the Seed Vault and a total of 41.720.649 seeds. These seeds have been harvested from 115 countries. Many seeds come from seed banks in Mexico, Ethiopia and Sweden, while only a few come from seed banks in the United Arab Emirates, the Norfolk Islands and Chad.

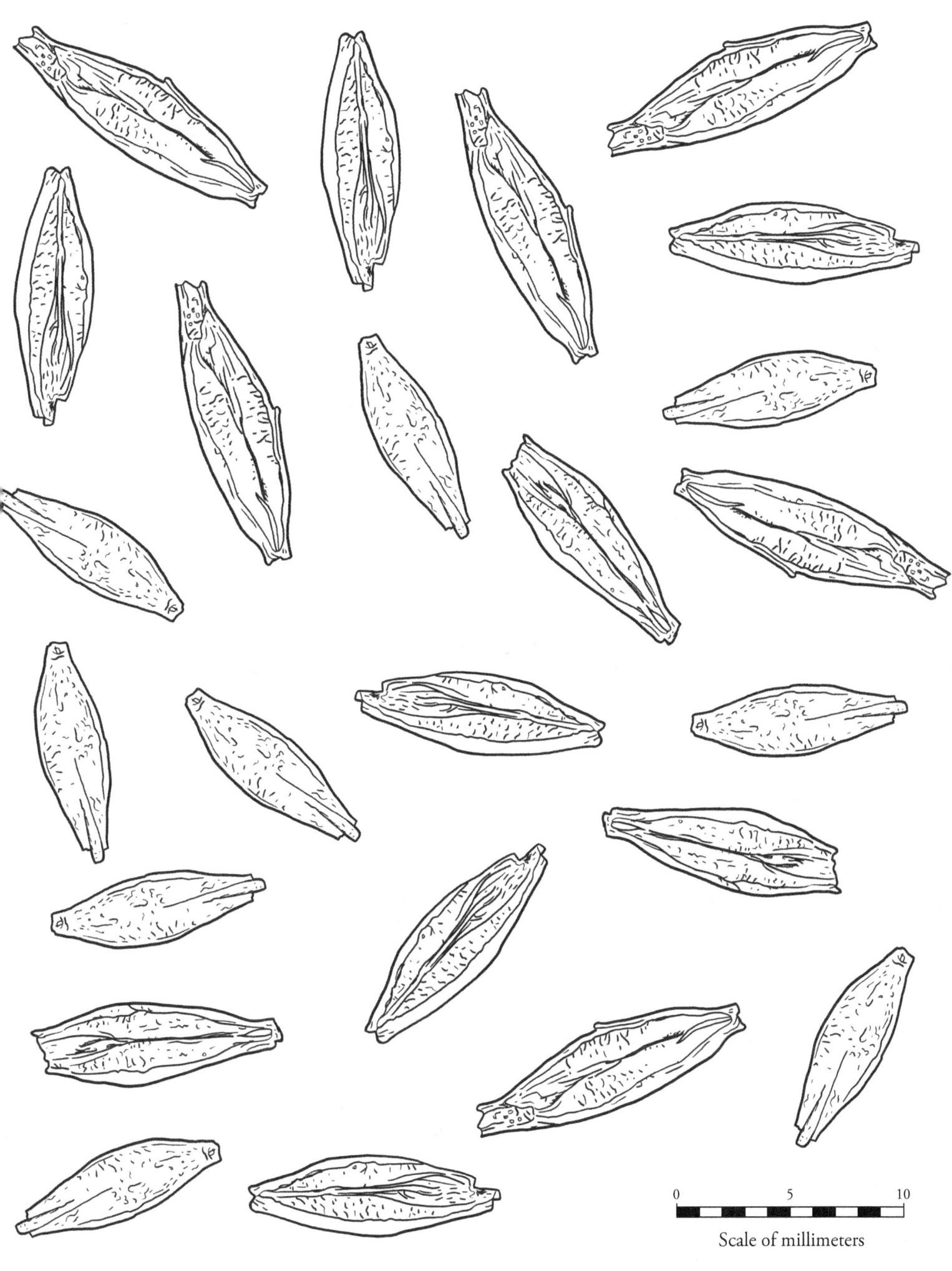

Scale of millimeters

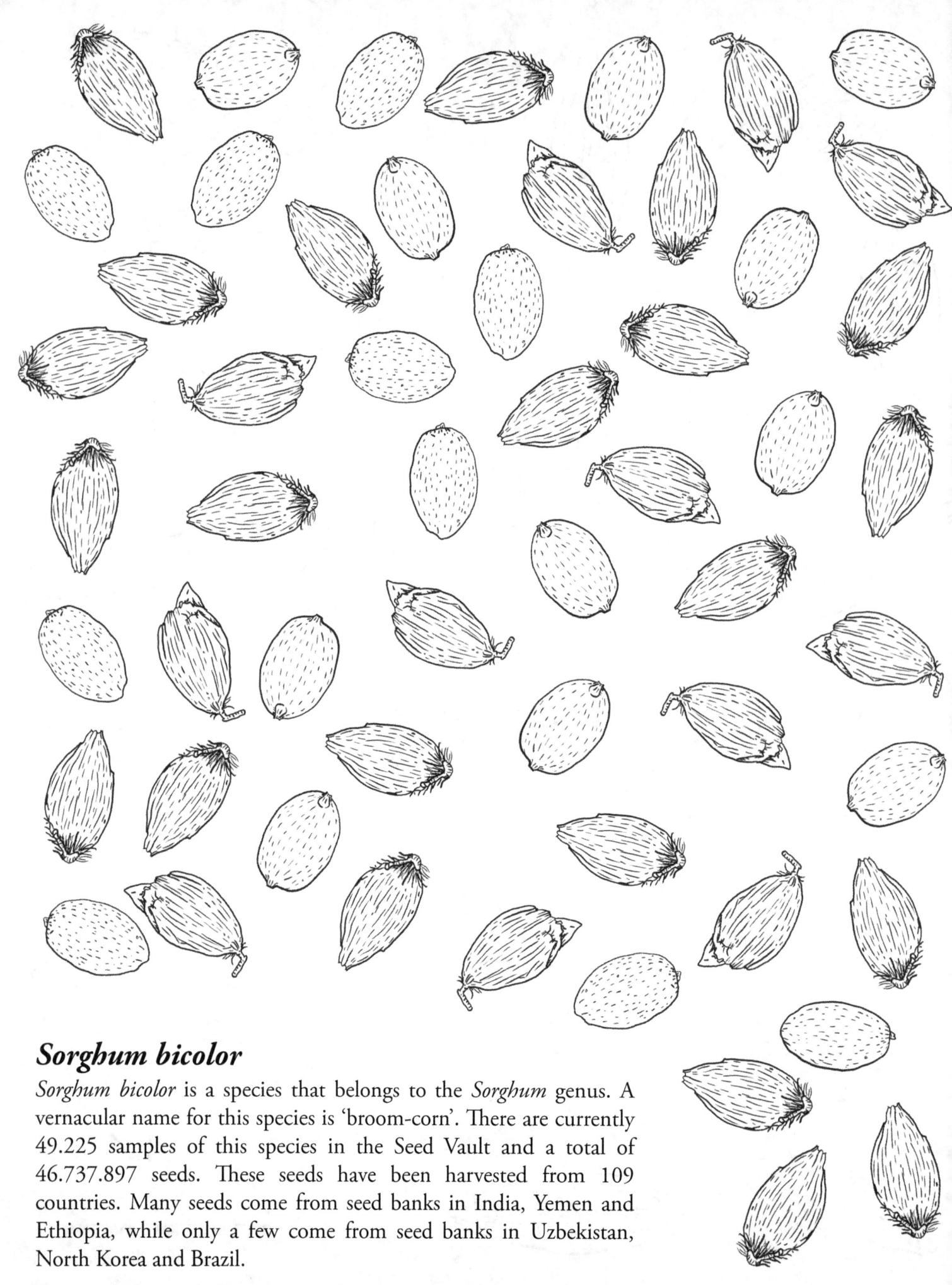

Sorghum bicolor

Sorghum bicolor is a species that belongs to the *Sorghum* genus. A vernacular name for this species is 'broom-corn'. There are currently 49.225 samples of this species in the Seed Vault and a total of 46.737.897 seeds. These seeds have been harvested from 109 countries. Many seeds come from seed banks in India, Yemen and Ethiopia, while only a few come from seed banks in Uzbekistan, North Korea and Brazil.

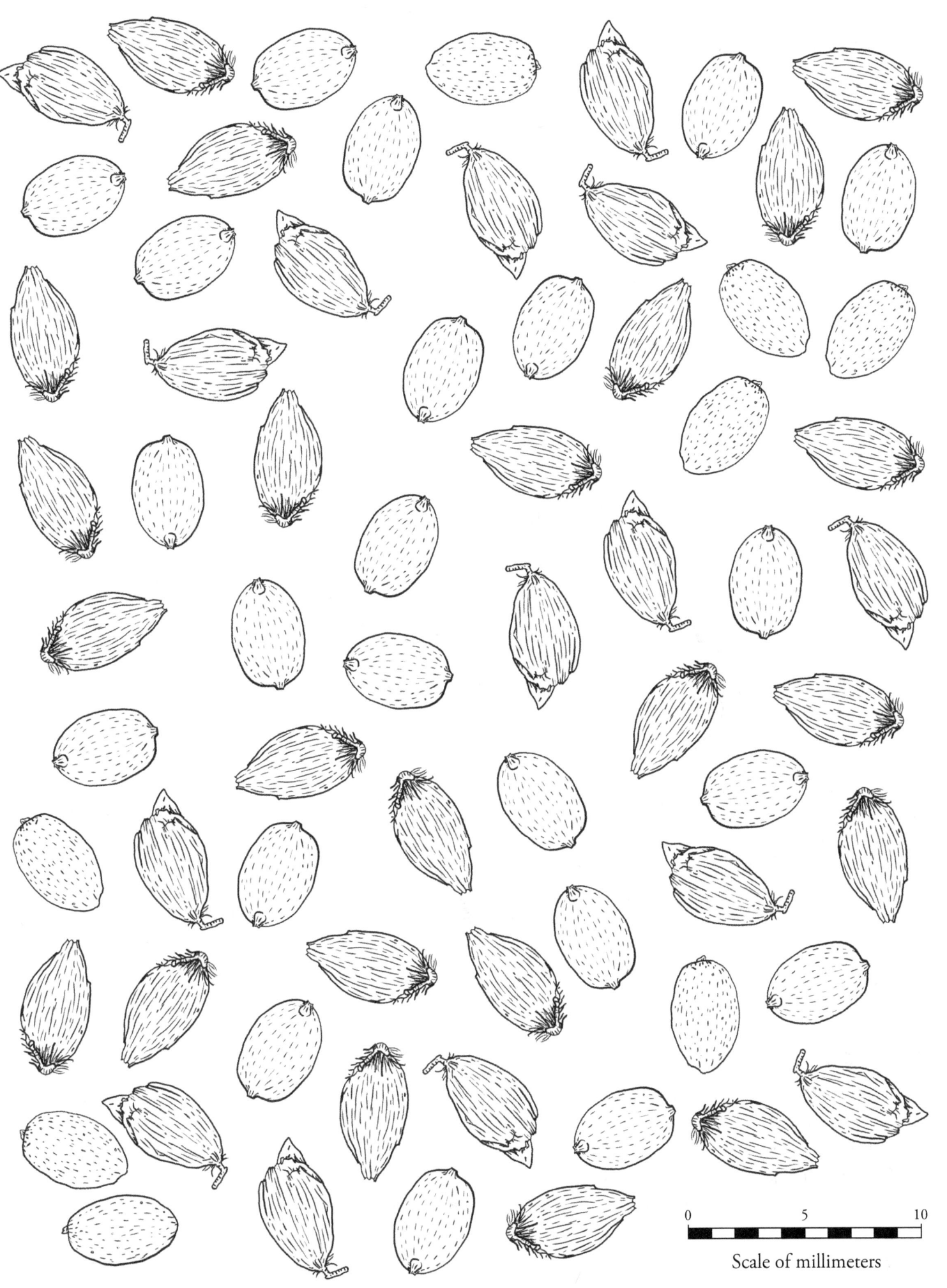

Scale of millimeters

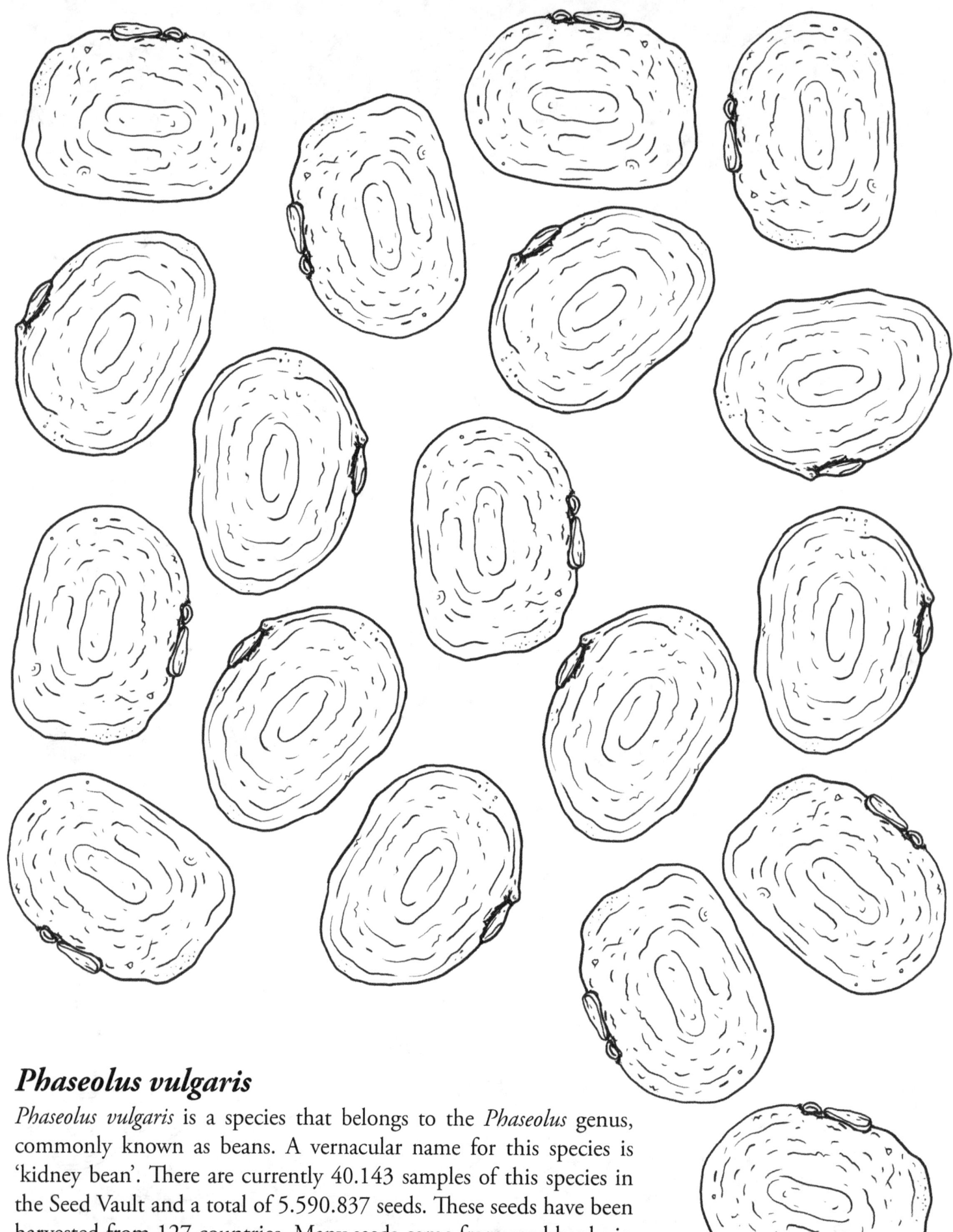

Phaseolus vulgaris

Phaseolus vulgaris is a species that belongs to the *Phaseolus* genus, commonly known as beans. A vernacular name for this species is 'kidney bean'. There are currently 40.143 samples of this species in the Seed Vault and a total of 5.590.837 seeds. These seeds have been harvested from 127 countries. Many seeds come from seed banks in Mexico, Peru and Colombia, while only a few come from seed banks in Belarus, Jordan and Sudan.

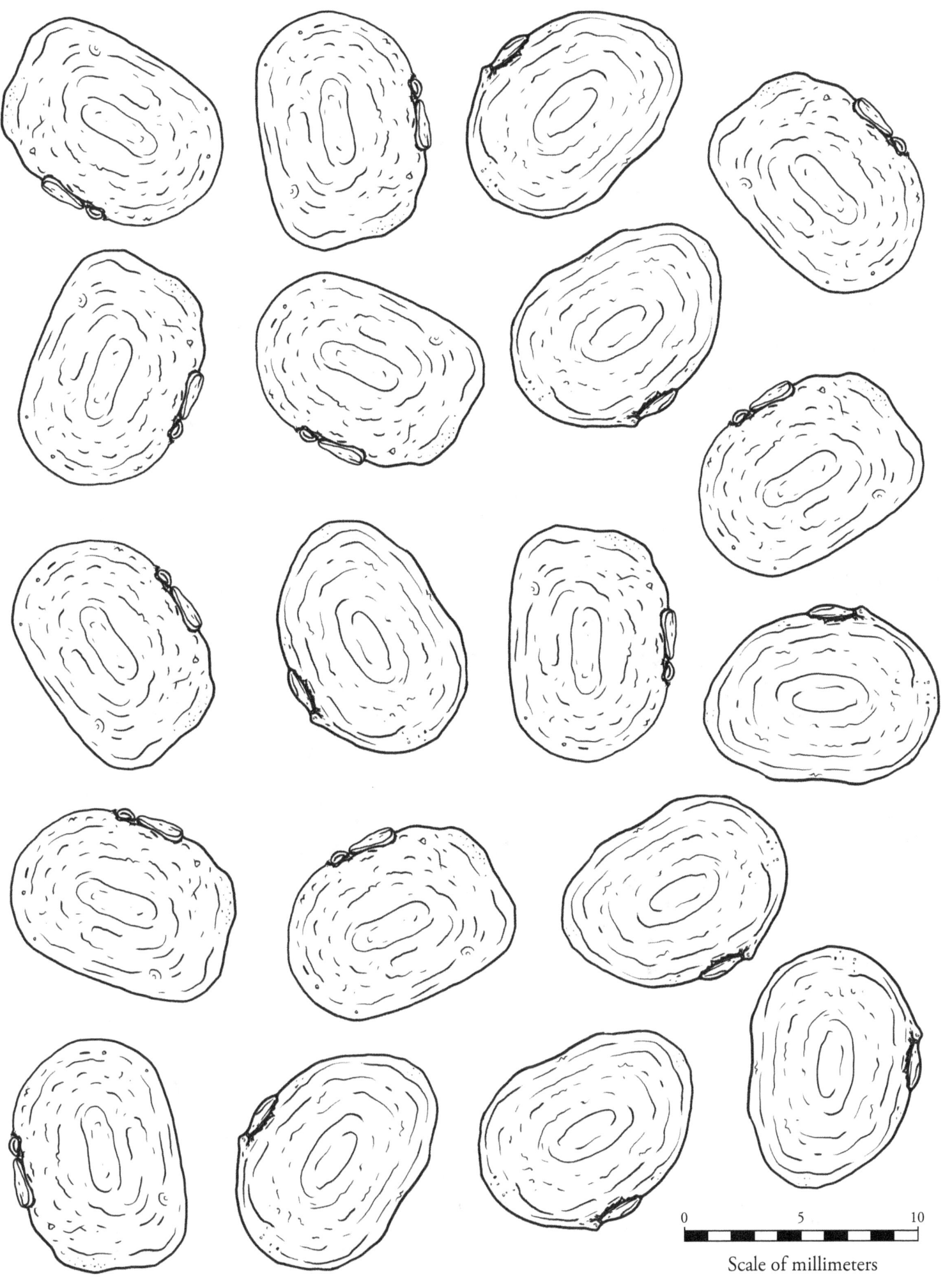

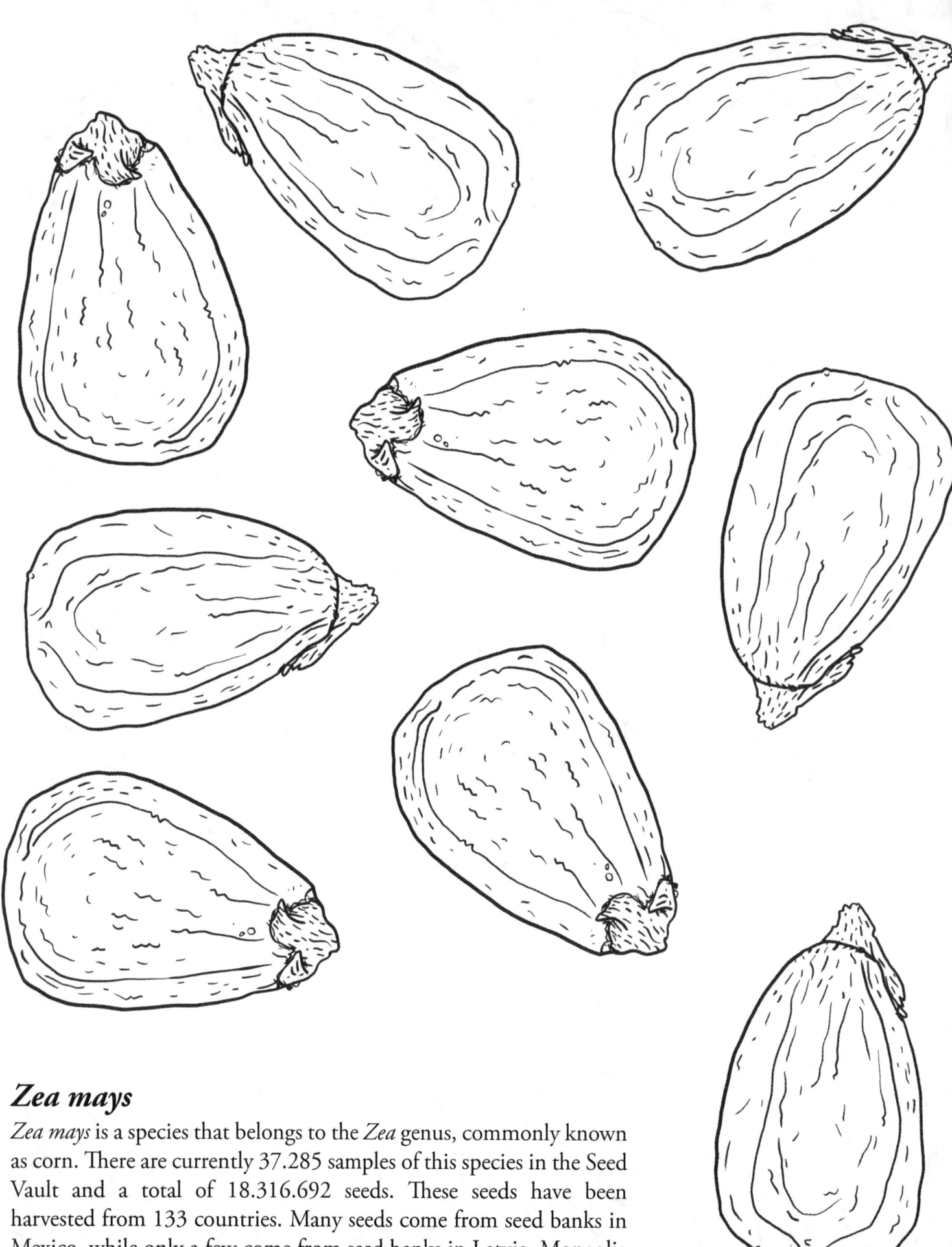

Zea mays

Zea mays is a species that belongs to the *Zea* genus, commonly known as corn. There are currently 37.285 samples of this species in the Seed Vault and a total of 18.316.692 seeds. These seeds have been harvested from 133 countries. Many seeds come from seed banks in Mexico, while only a few come from seed banks in Latvia, Mongolia and Sweden.

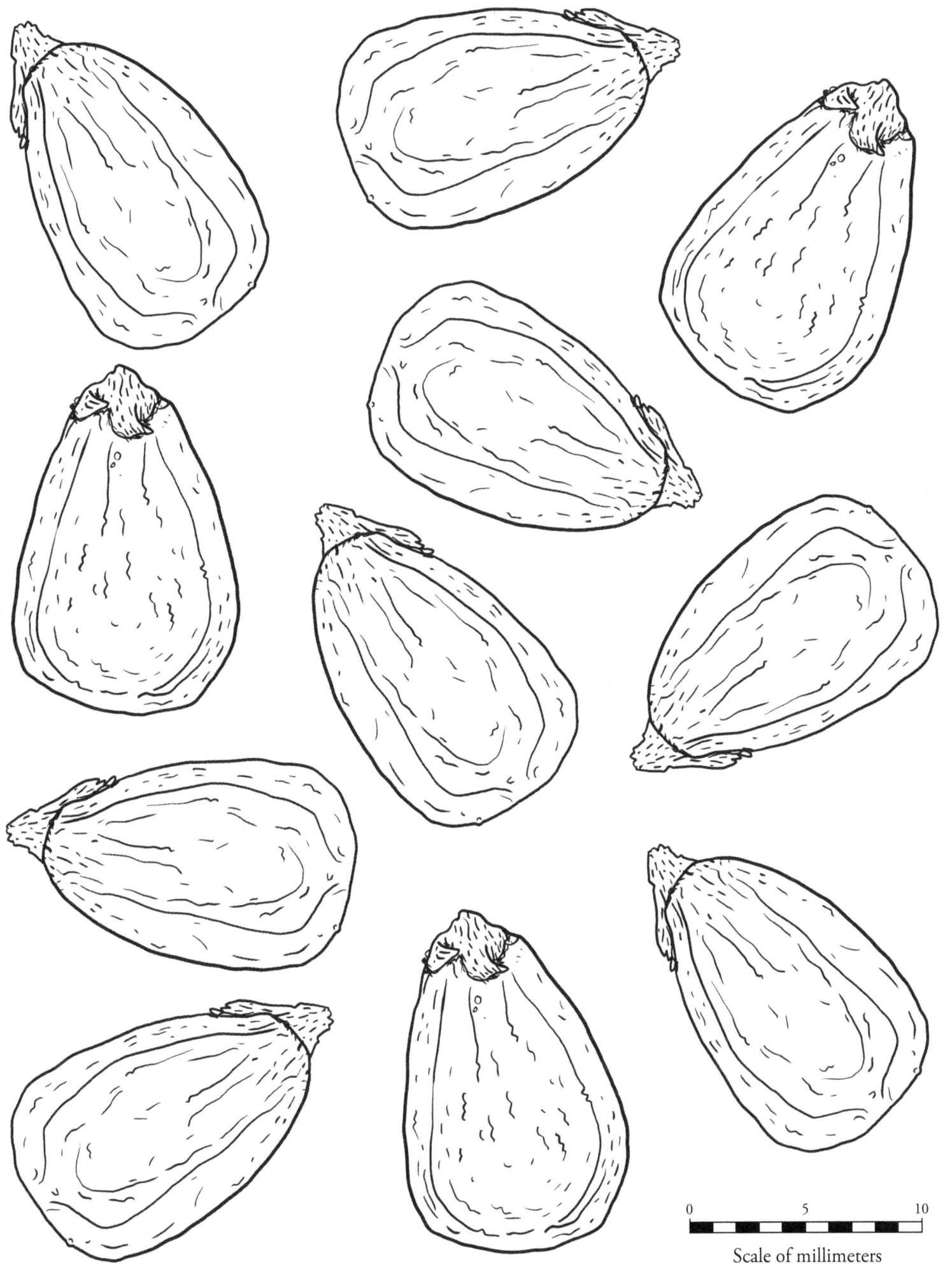

Scale of millimeters

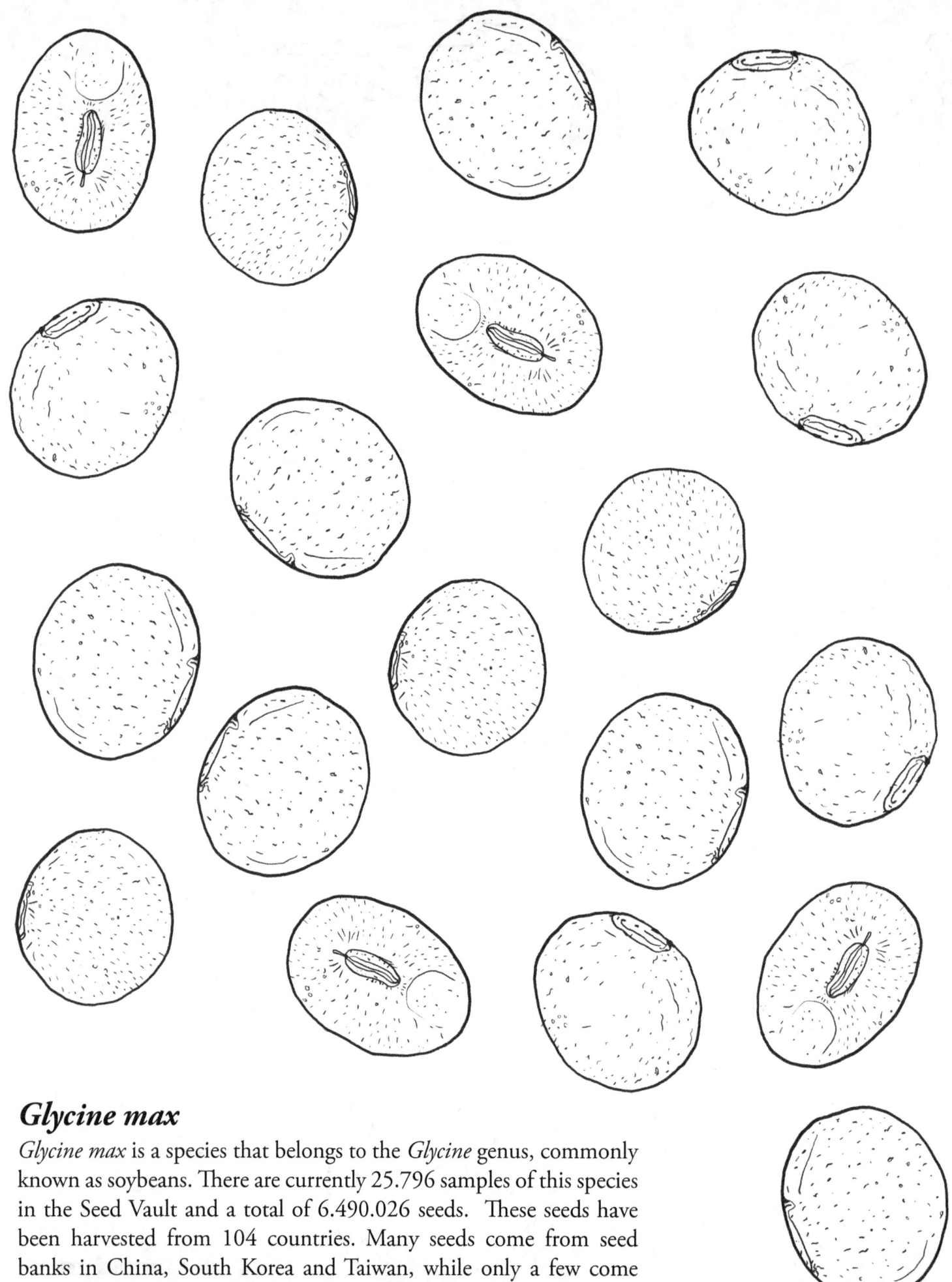

Glycine max

Glycine max is a species that belongs to the *Glycine* genus, commonly known as soybeans. There are currently 25.796 samples of this species in the Seed Vault and a total of 6.490.026 seeds. These seeds have been harvested from 104 countries. Many seeds come from seed banks in China, South Korea and Taiwan, while only a few come from seed banks in Iran, Denmark and Sri Lanka.

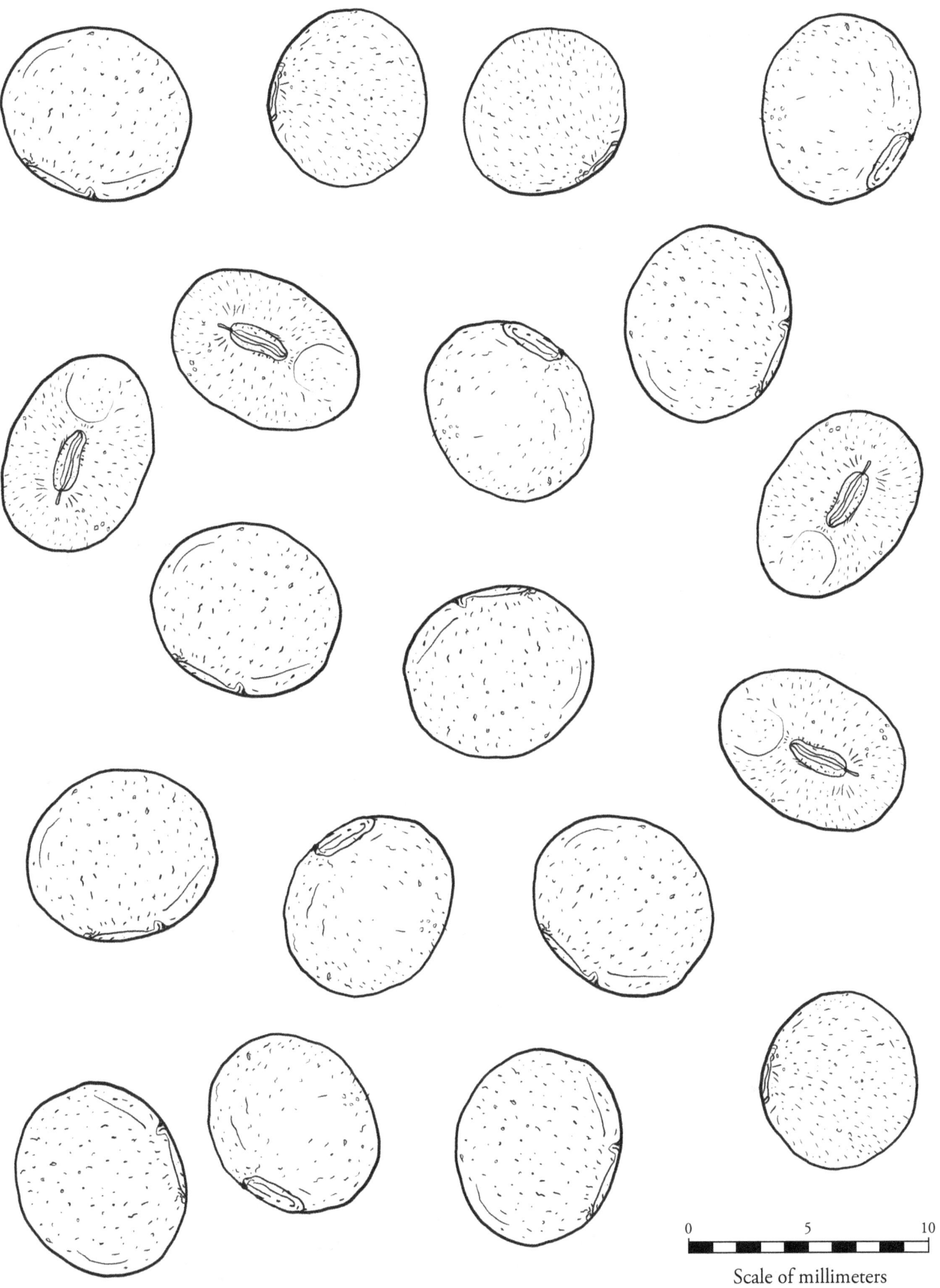

Scale of millimeters

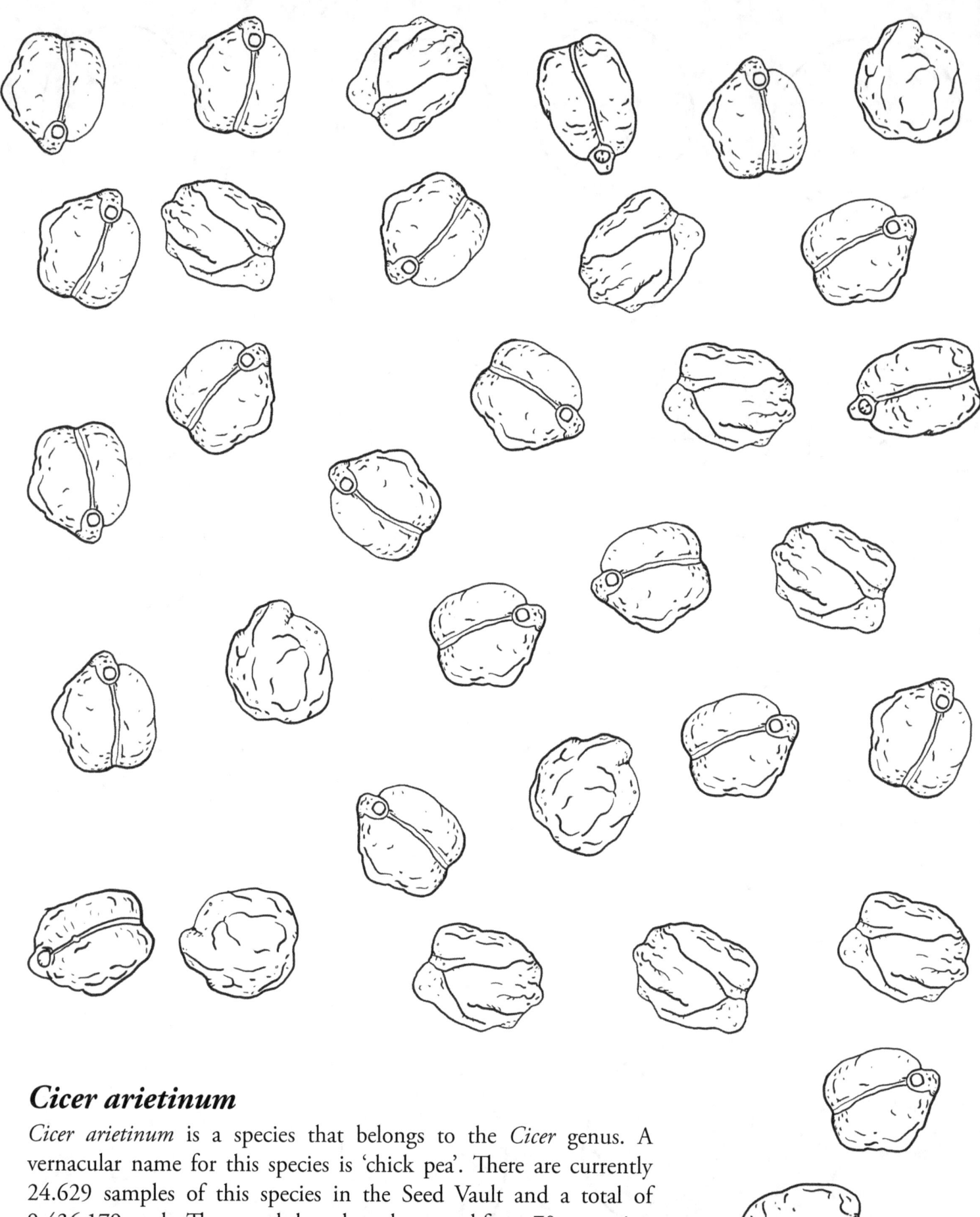

Cicer arietinum

Cicer arietinum is a species that belongs to the *Cicer* genus. A vernacular name for this species is 'chick pea'. There are currently 24.629 samples of this species in the Seed Vault and a total of 9.436.179 seeds. These seeds have been harvested from 70 countries. Many seeds come from seed banks in India and Iran, while only a few come from seed banks in Uganda, Romania and the Netherlands.

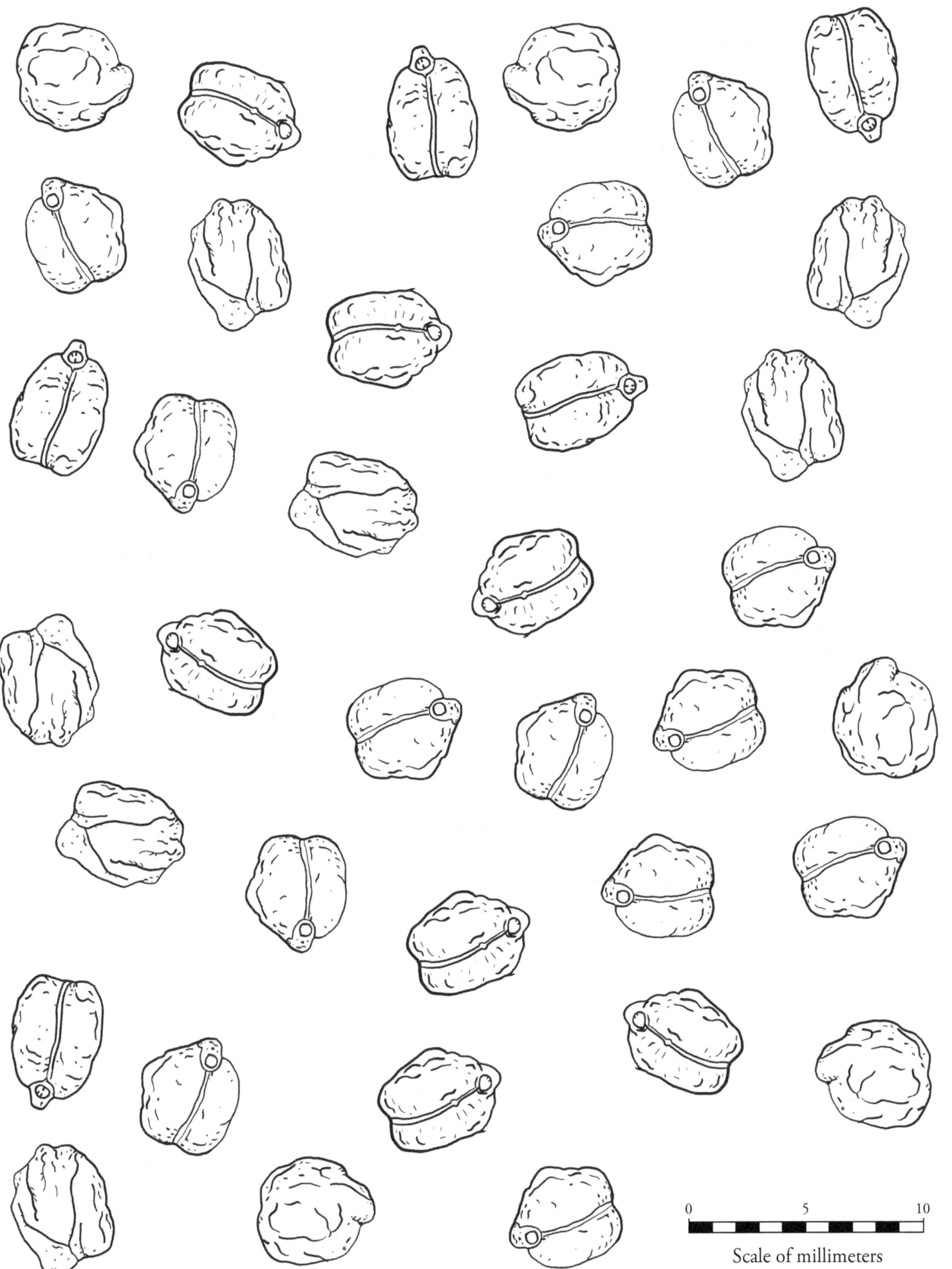

Scale of millimeters

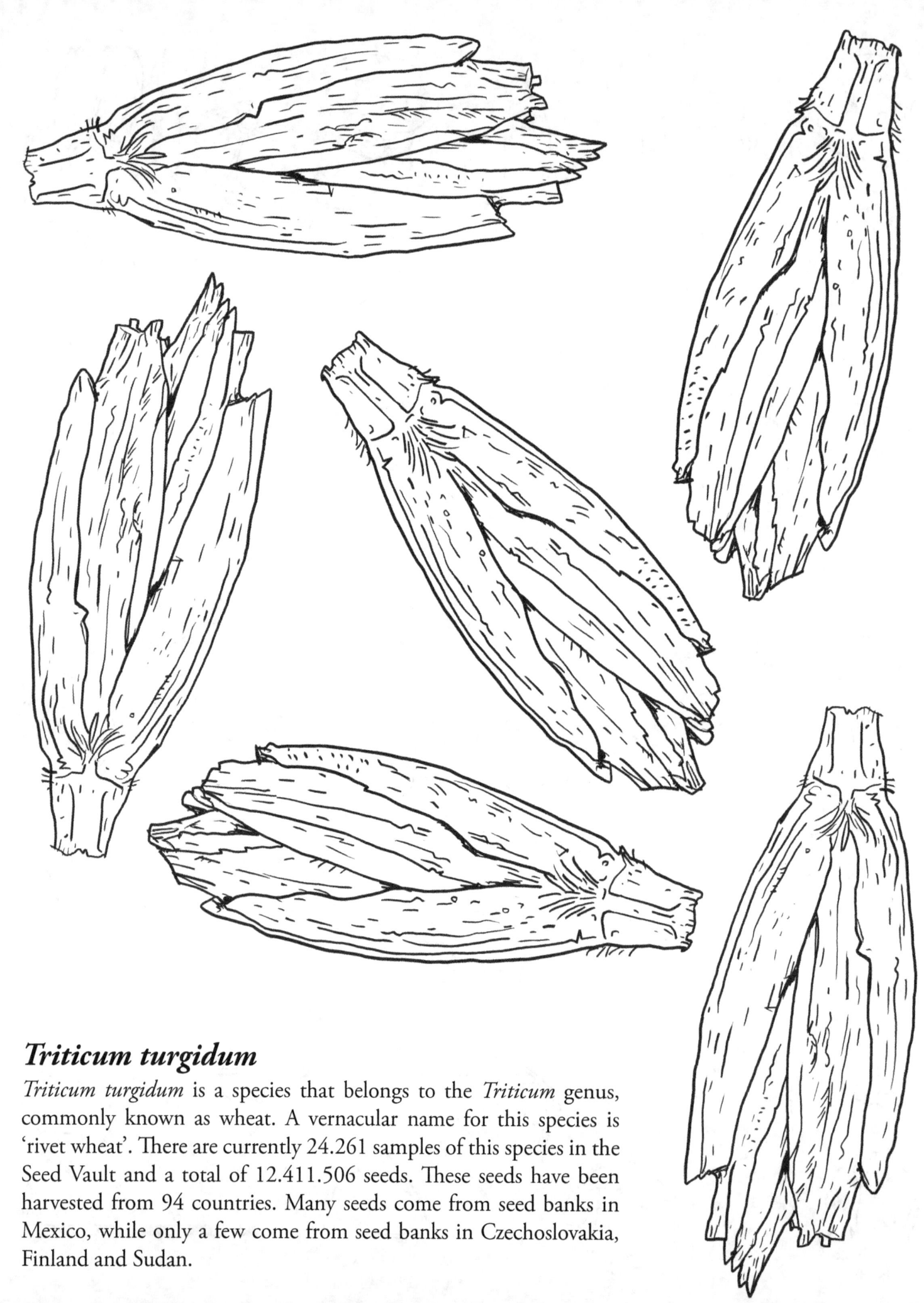

Triticum turgidum

Triticum turgidum is a species that belongs to the *Triticum* genus, commonly known as wheat. A vernacular name for this species is 'rivet wheat'. There are currently 24.261 samples of this species in the Seed Vault and a total of 12.411.506 seeds. These seeds have been harvested from 94 countries. Many seeds come from seed banks in Mexico, while only a few come from seed banks in Czechoslovakia, Finland and Sudan.

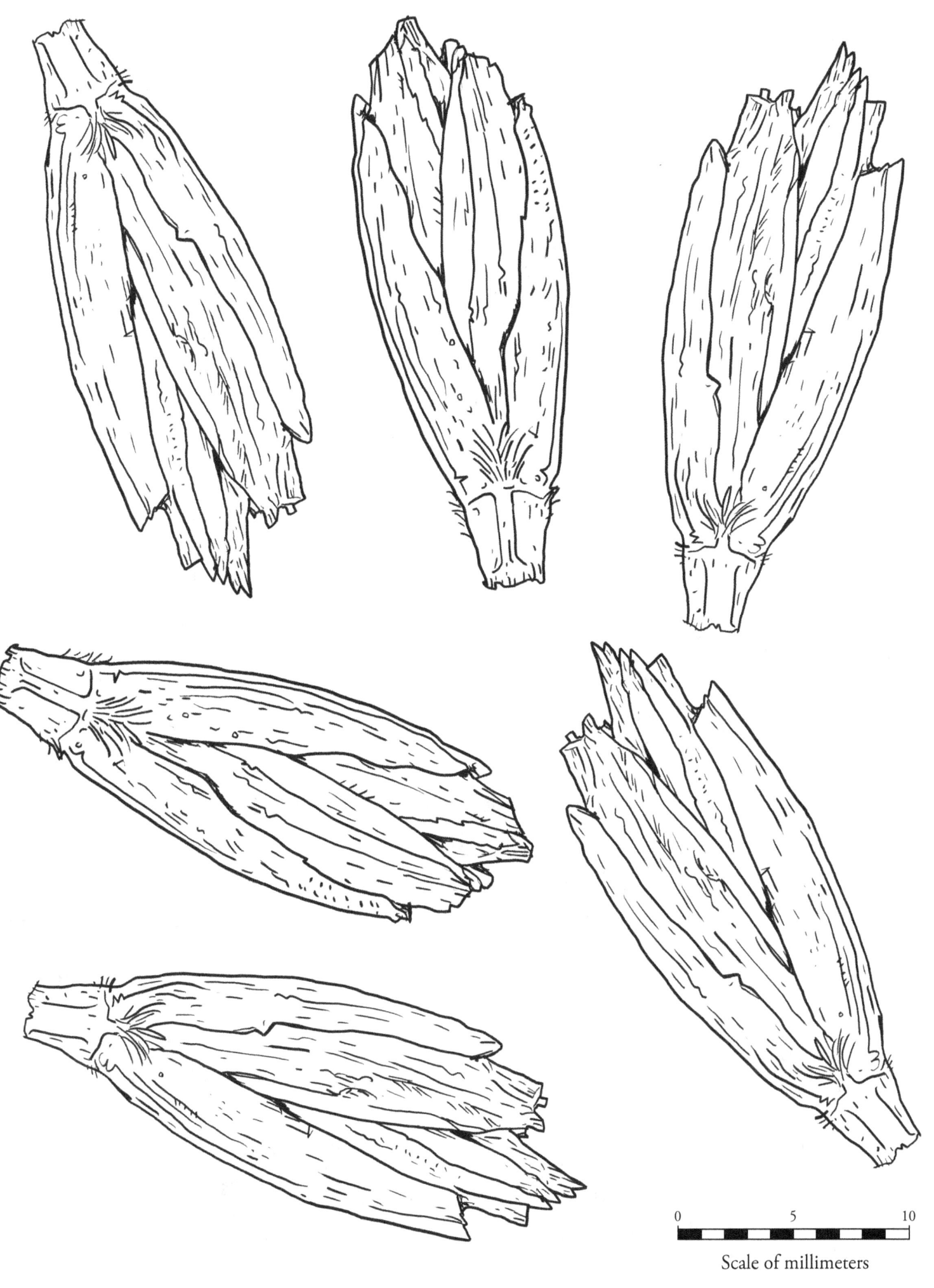

Scale of millimeters

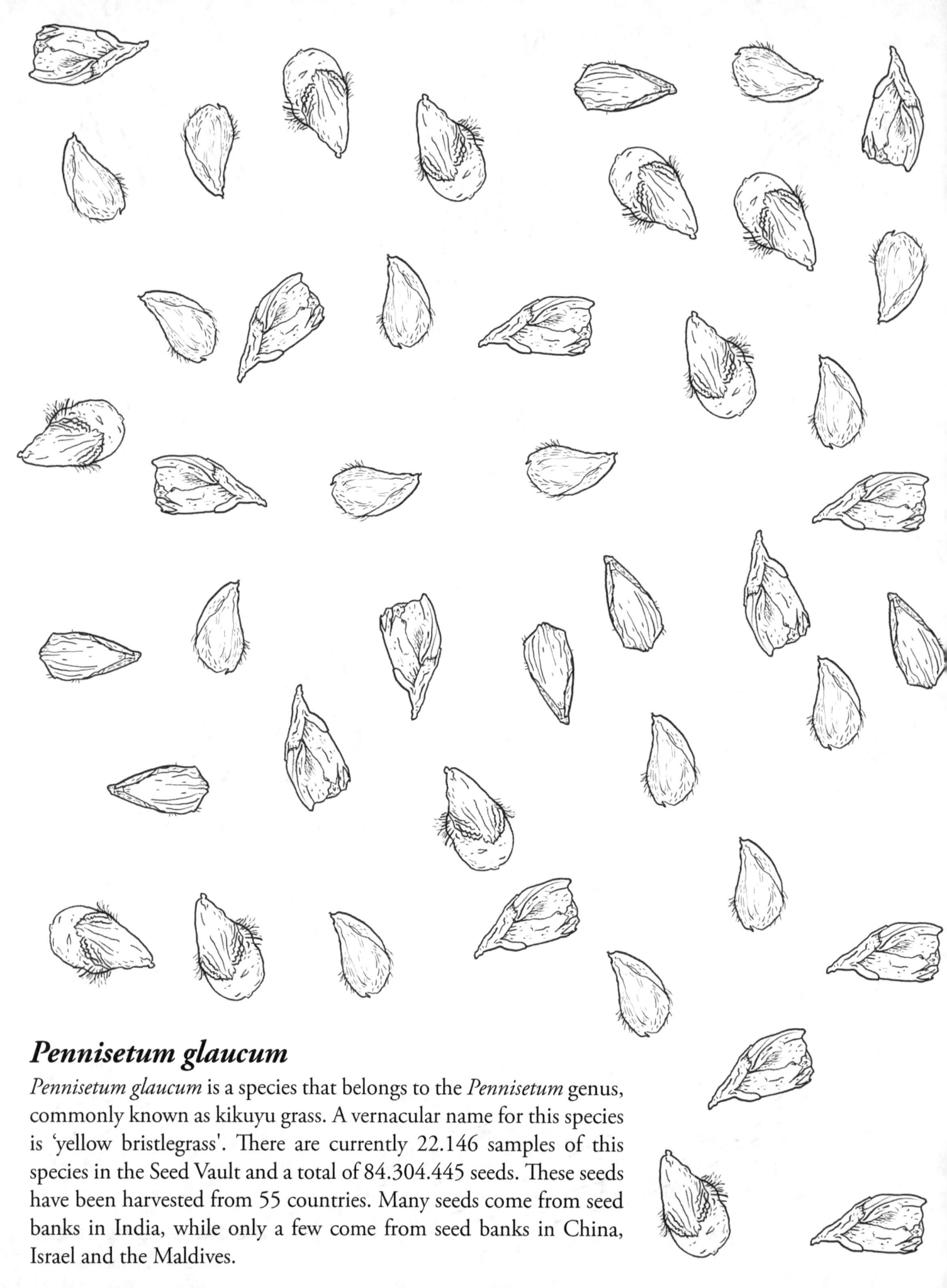

Pennisetum glaucum

Pennisetum glaucum is a species that belongs to the *Pennisetum* genus, commonly known as kikuyu grass. A vernacular name for this species is 'yellow bristlegrass'. There are currently 22.146 samples of this species in the Seed Vault and a total of 84.304.445 seeds. These seeds have been harvested from 55 countries. Many seeds come from seed banks in India, while only a few come from seed banks in China, Israel and the Maldives.

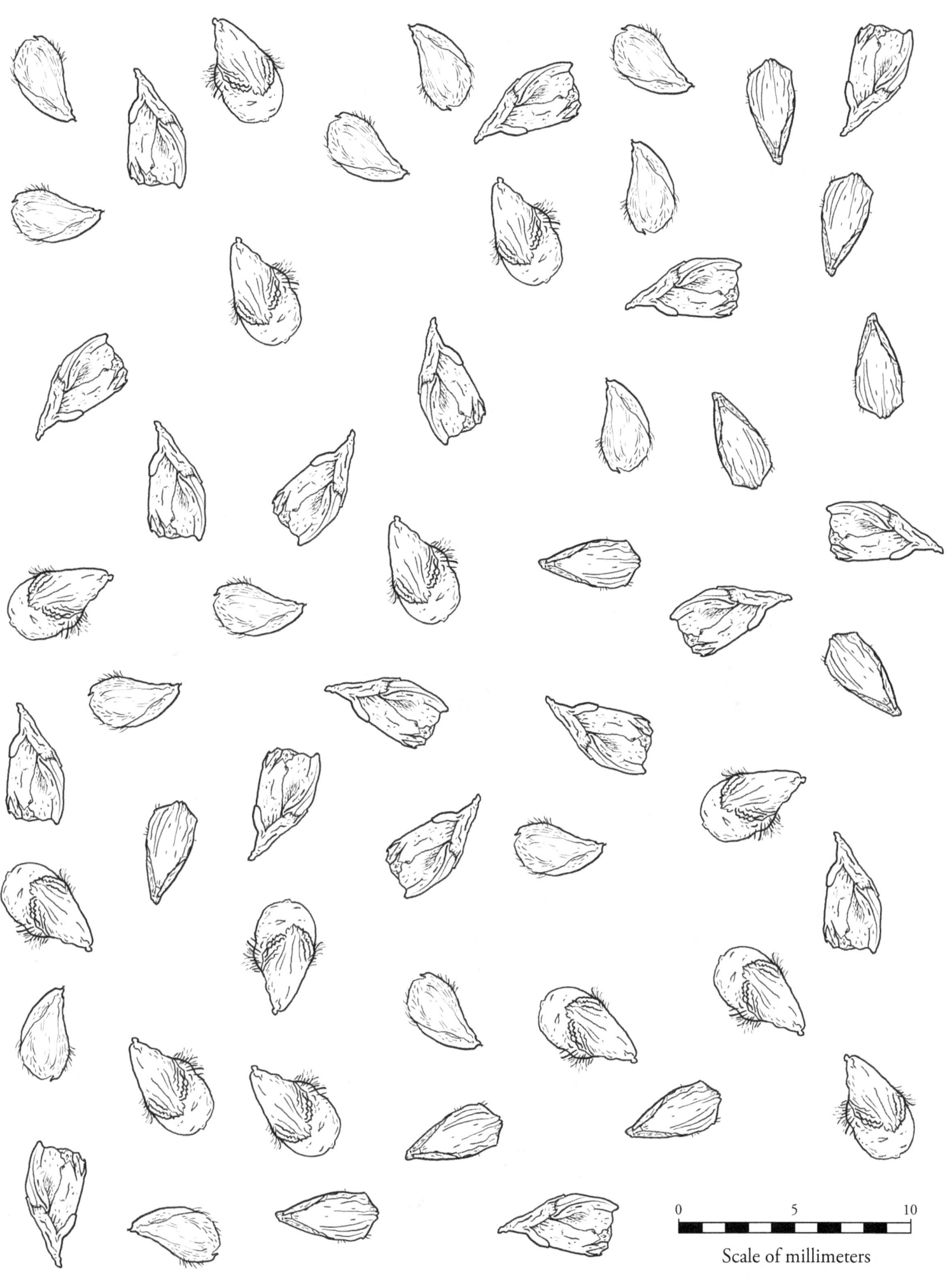

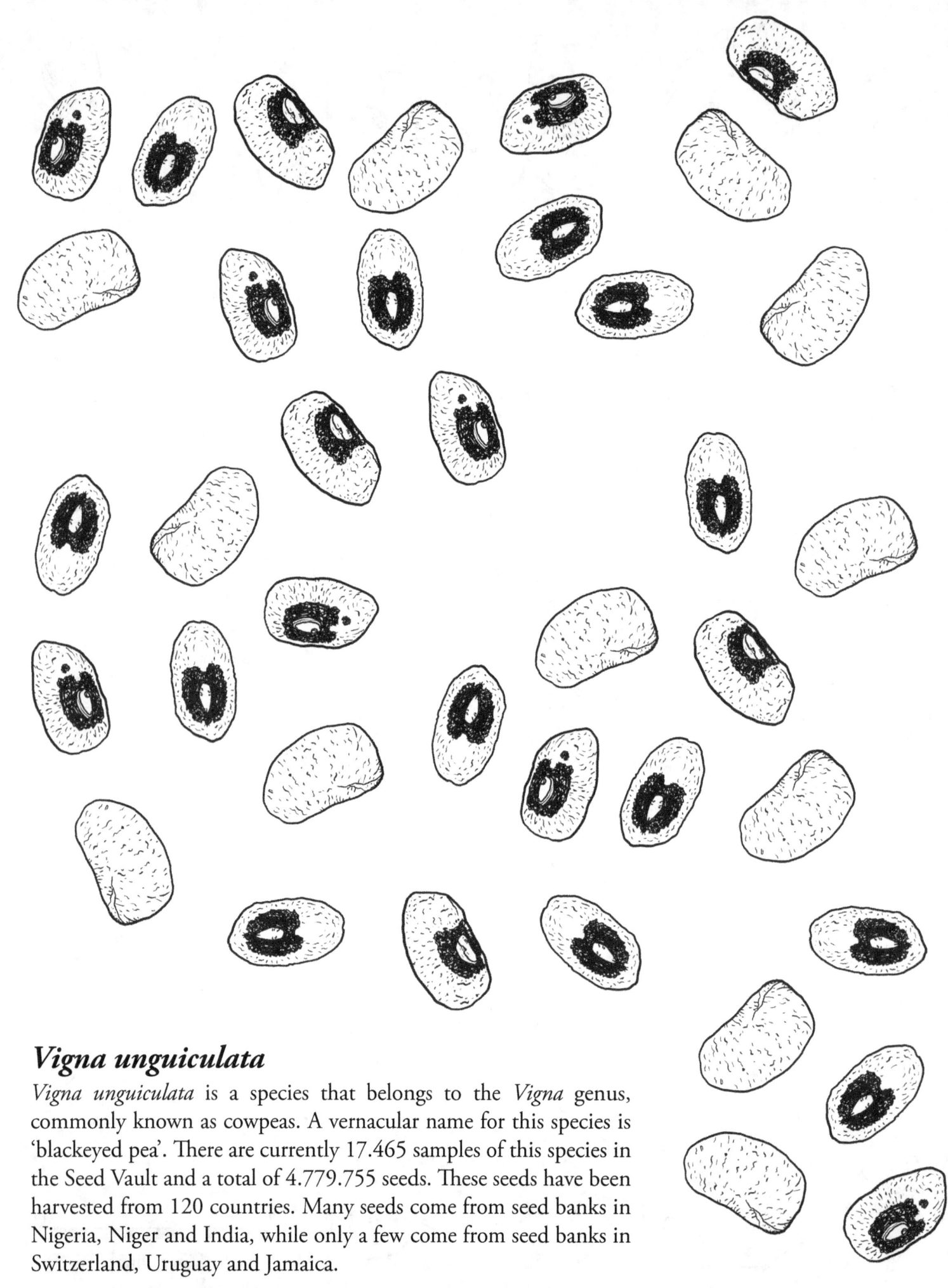

Vigna unguiculata

Vigna unguiculata is a species that belongs to the *Vigna* genus, commonly known as cowpeas. A vernacular name for this species is 'blackeyed pea'. There are currently 17.465 samples of this species in the Seed Vault and a total of 4.779.755 seeds. These seeds have been harvested from 120 countries. Many seeds come from seed banks in Nigeria, Niger and India, while only a few come from seed banks in Switzerland, Uruguay and Jamaica.

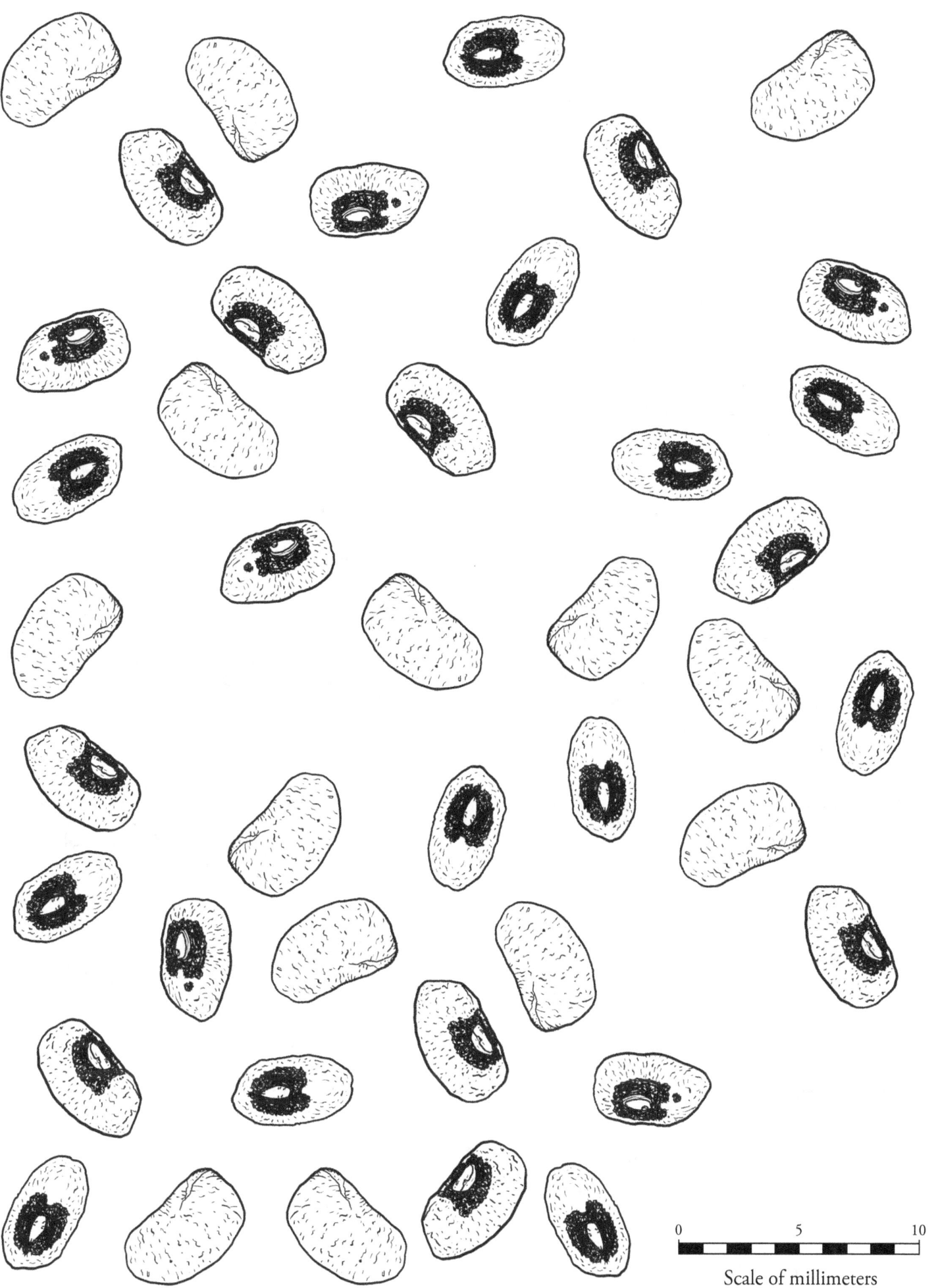

Scale of millimeters

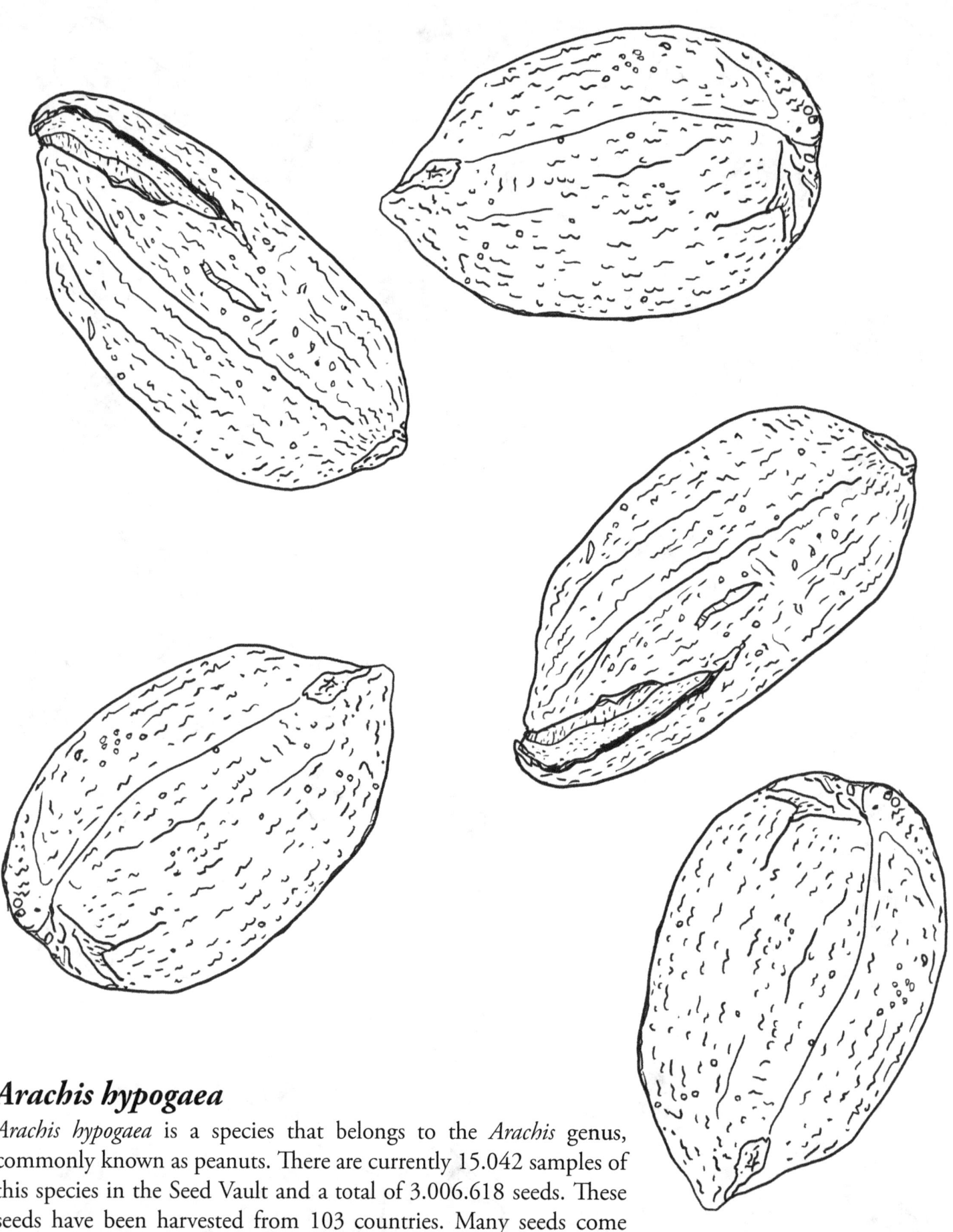

Arachis hypogaea

Arachis hypogaea is a species that belongs to the *Arachis* genus, commonly known as peanuts. There are currently 15.042 samples of this species in the Seed Vault and a total of 3.006.618 seeds. These seeds have been harvested from 103 countries. Many seeds come from seed banks in India, the USA and Brazil, while only a few come from seed banks in Yemen, Syria and France.

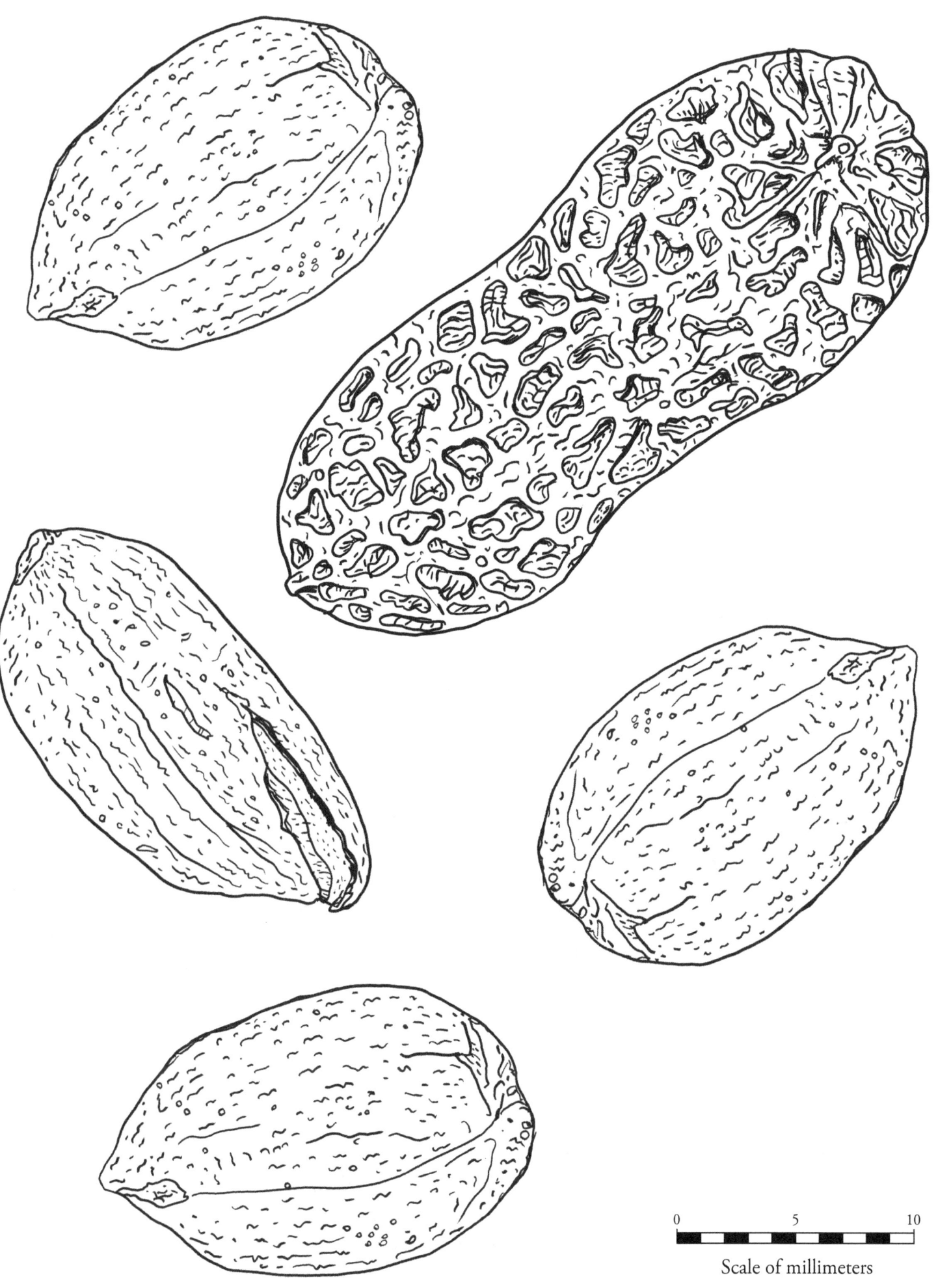

Scale of millimeters

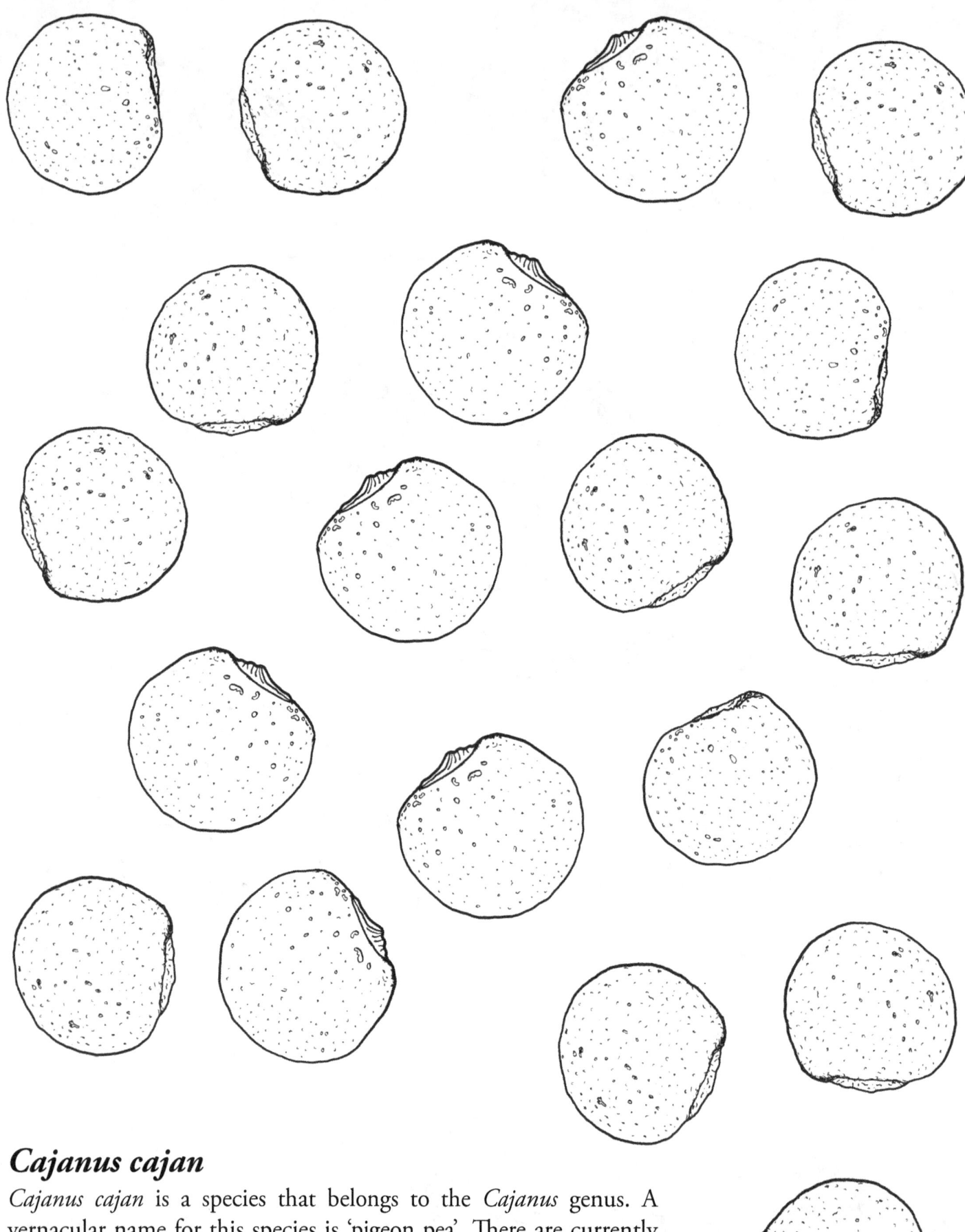

Cajanus cajan

Cajanus cajan is a species that belongs to the *Cajanus* genus. A vernacular name for this species is 'pigeon pea'. There are currently 12.893 samples of this species in the Seed Vault and a total of 4.996.149 seeds. These seeds have been harvested from 65 countries. Many seeds come from seed banks in India, while only a few come from seed banks in Laos, Panama and Suriname.

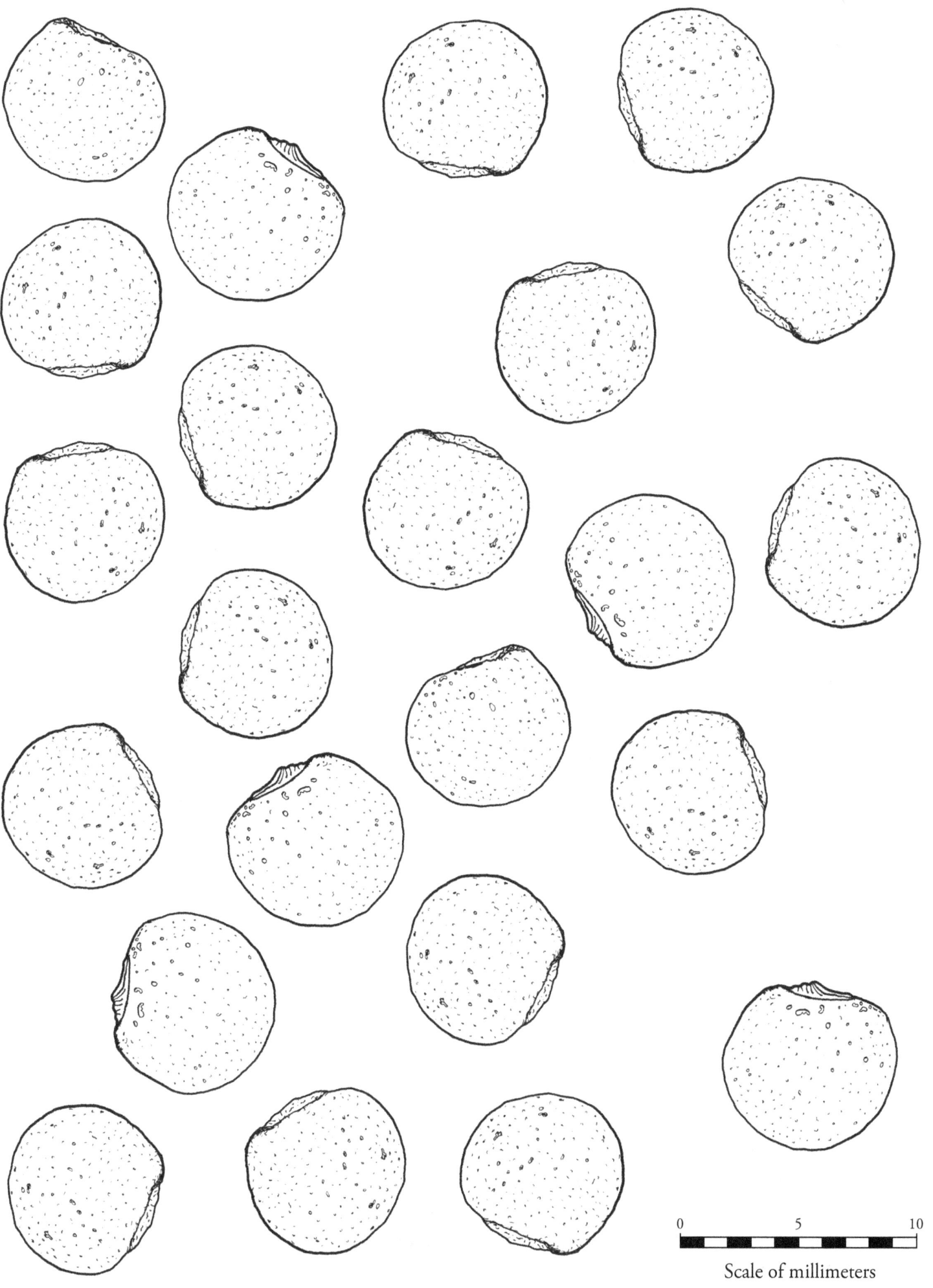
Scale of millimeters

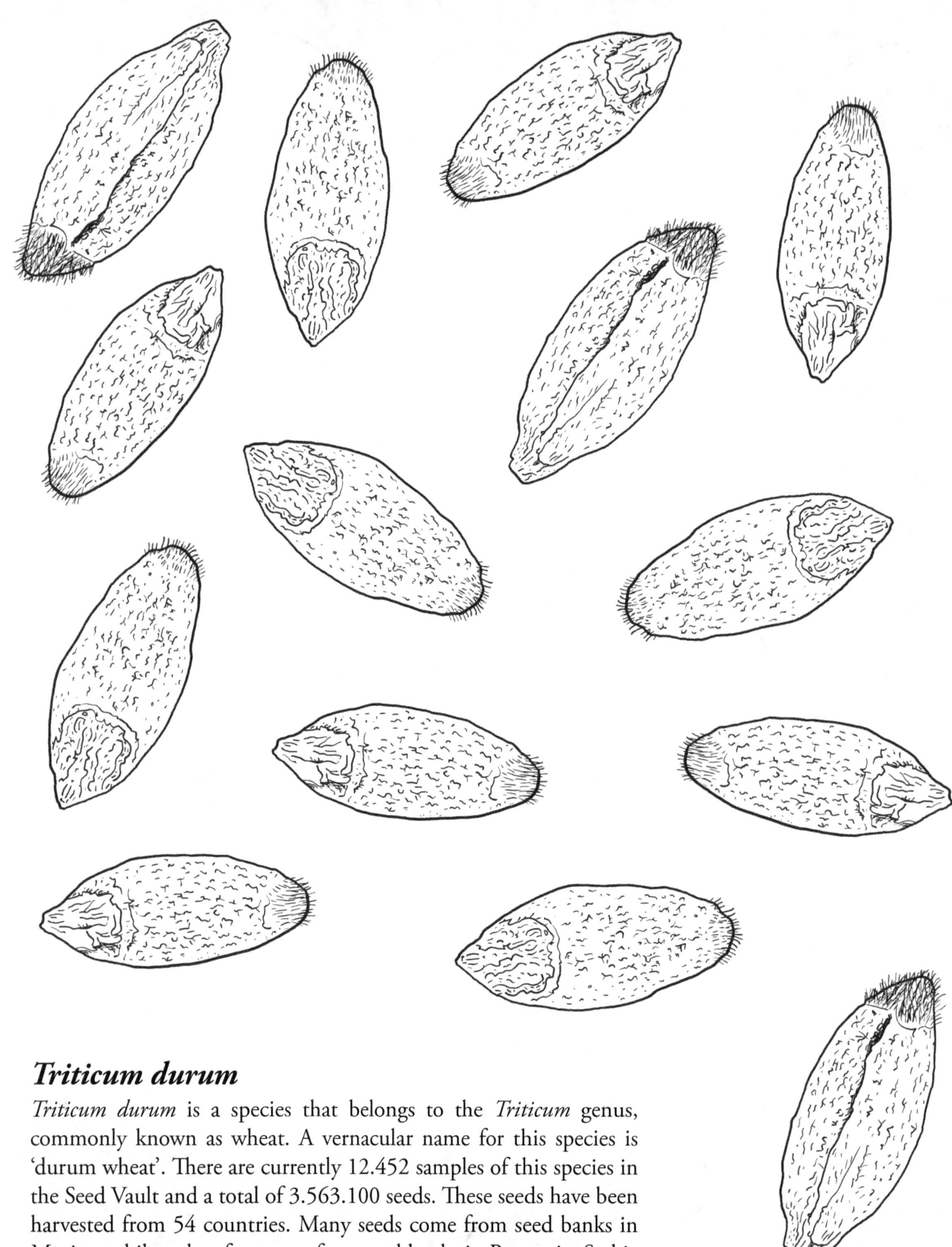

Triticum durum

Triticum durum is a species that belongs to the *Triticum* genus, commonly known as wheat. A vernacular name for this species is 'durum wheat'. There are currently 12.452 samples of this species in the Seed Vault and a total of 3.563.100 seeds. These seeds have been harvested from 54 countries. Many seeds come from seed banks in Mexico, while only a few come from seed banks in Romania, Serbia and Montenegro, and Sudan.

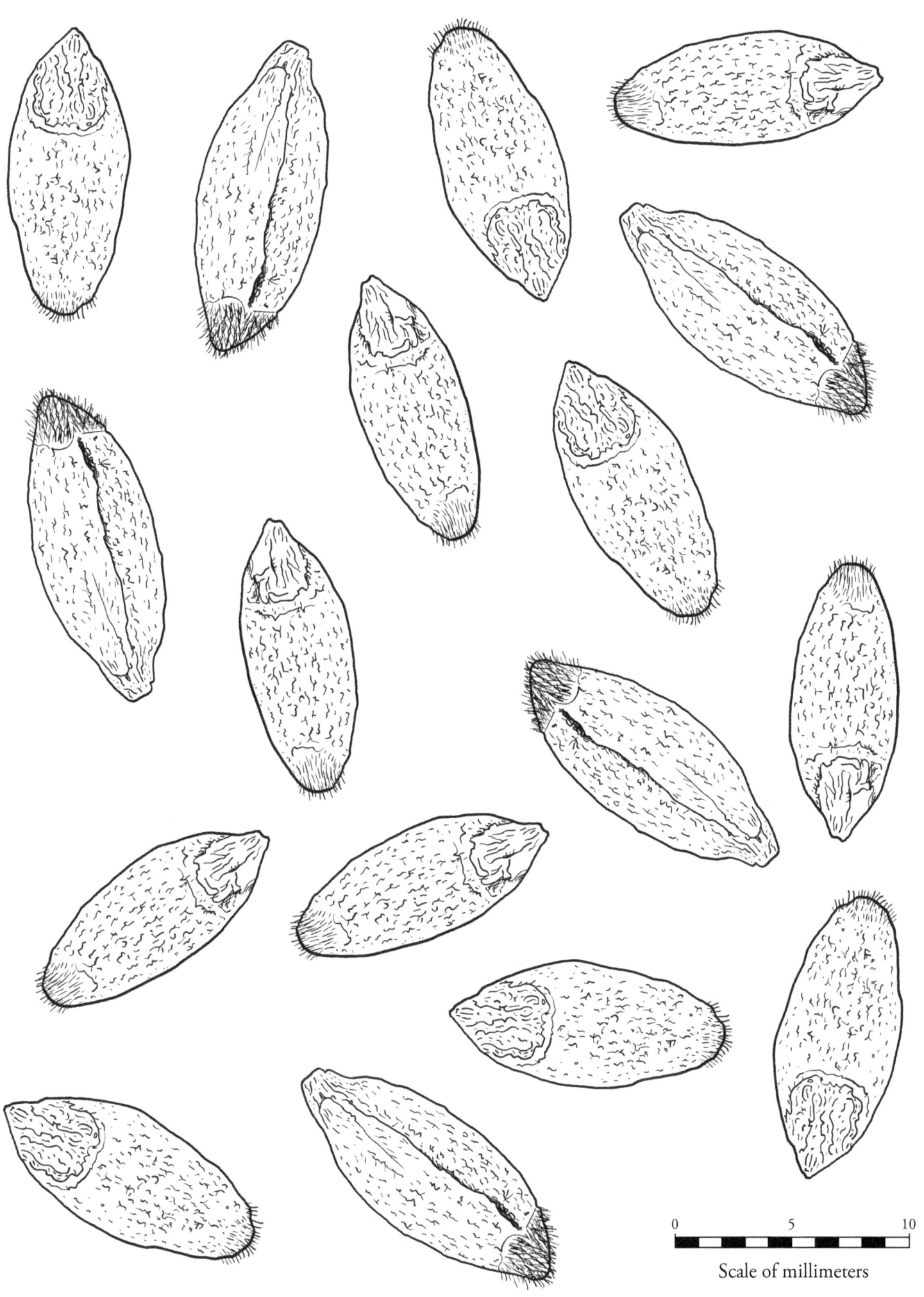

Scale of millimeters

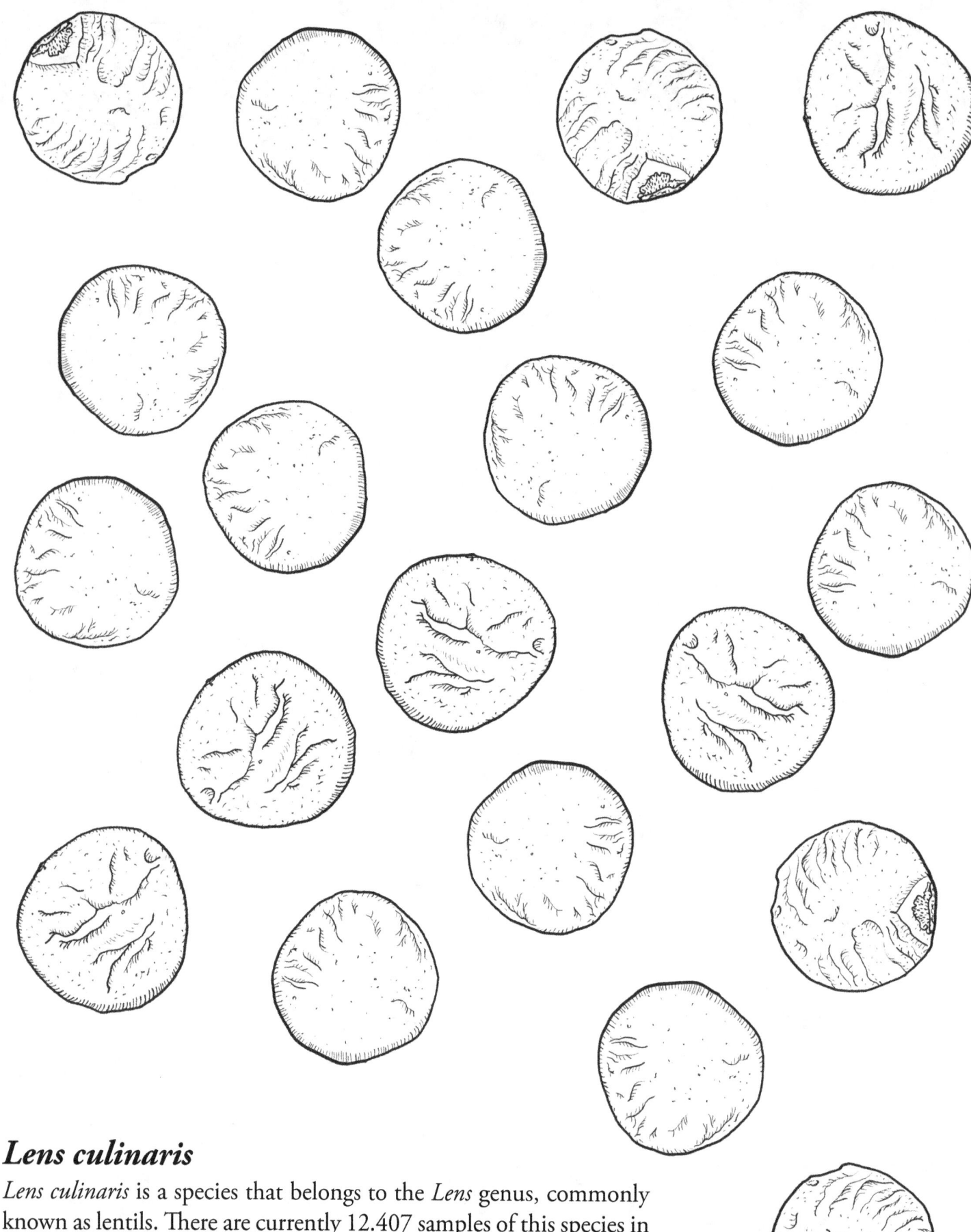

Lens culinaris

Lens culinaris is a species that belongs to the *Lens* genus, commonly known as lentils. There are currently 12.407 samples of this species in the Seed Vault and a total of 6.935.125 seeds. These seeds have been harvested from 78 countries. Many seeds come from seed banks in India, Iran and Pakistan, while only a few come from seed banks in Norway, Moldova and Cuba.

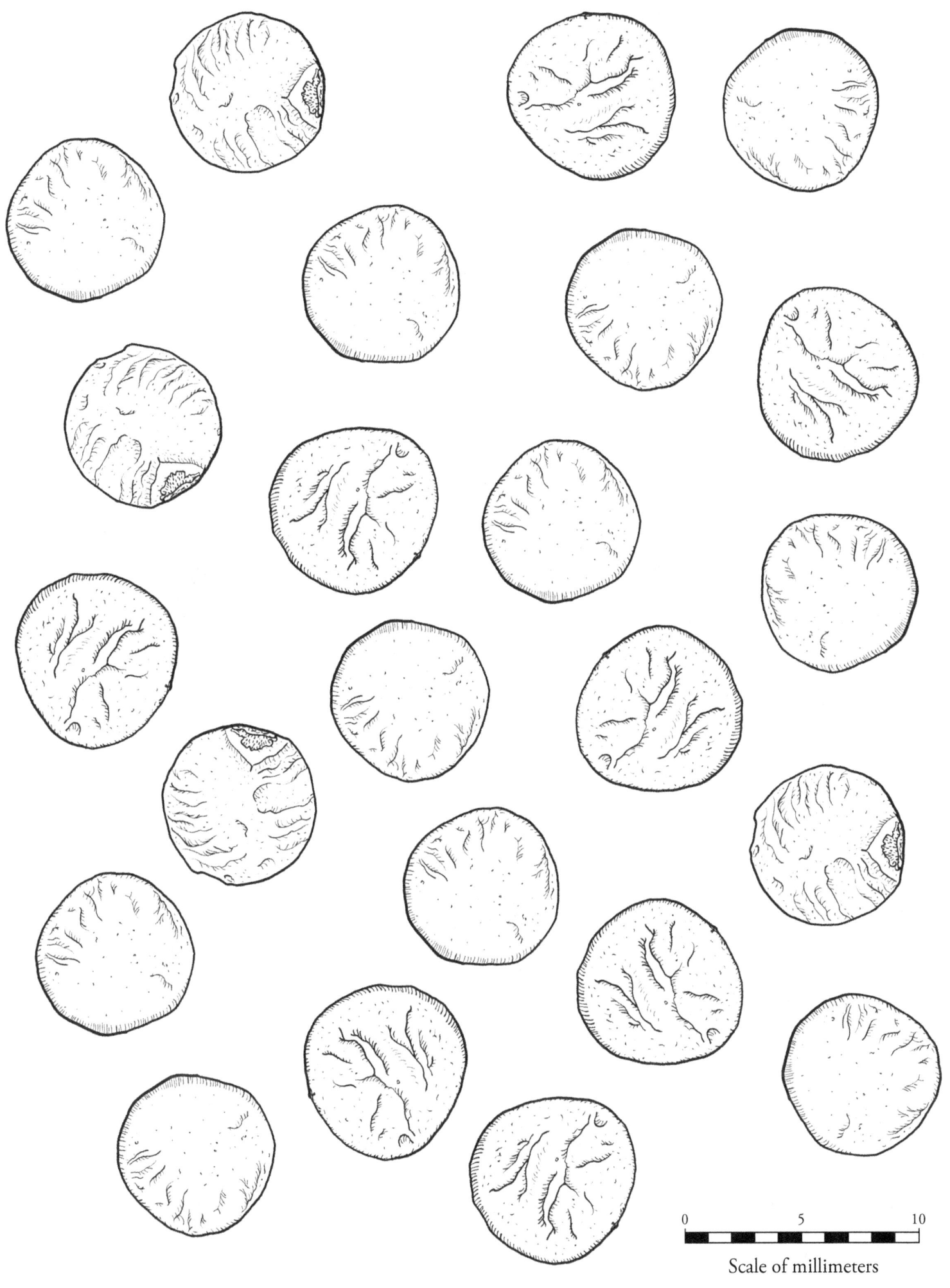

Scale of millimeters

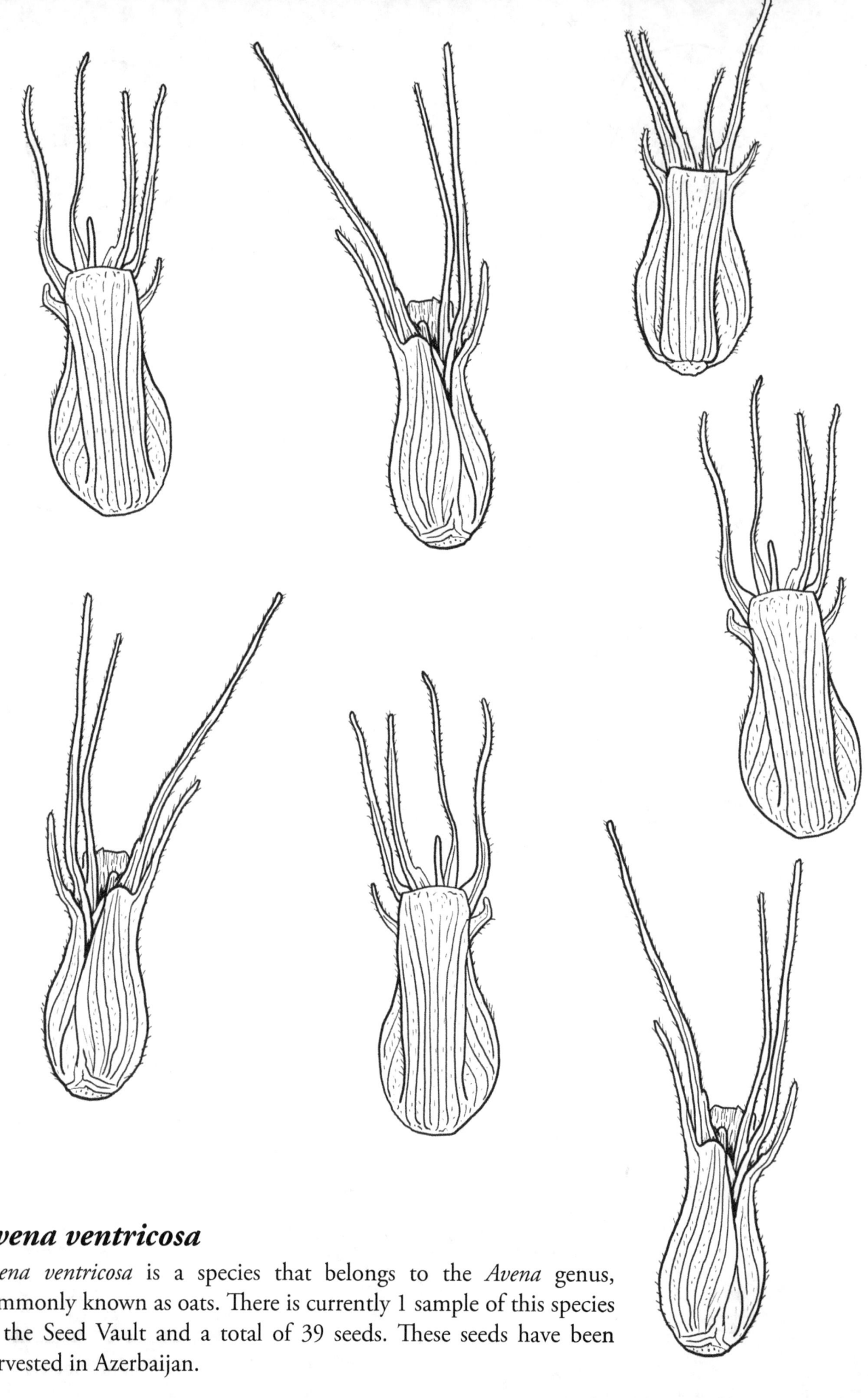

Avena ventricosa

Avena ventricosa is a species that belongs to the *Avena* genus, commonly known as oats. There is currently 1 sample of this species in the Seed Vault and a total of 39 seeds. These seeds have been harvested in Azerbaijan.

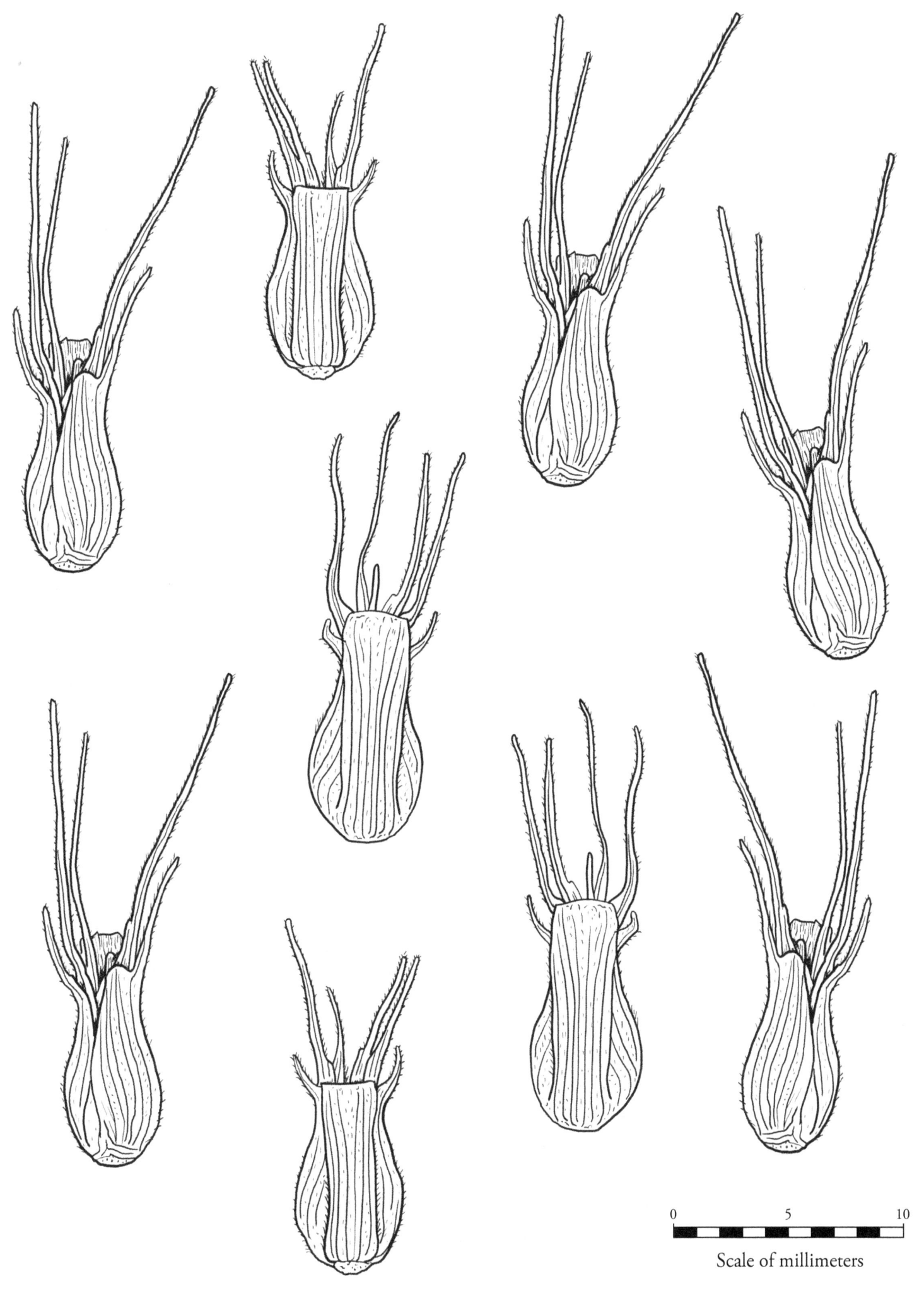

Scale of millimeters

Crotalaria longirostrata

Crotalaria longirostrata is a species that belongs to the *Crotalaria* genus, common names include devil-bean and rattleweed. A vernacular name for this species is 'longbeak rattlebox'. There is currently 1 sample of this species in the Seed Vault and a total of 50 seeds. These seeds have been harvested in El Salvador.

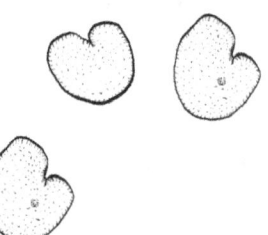

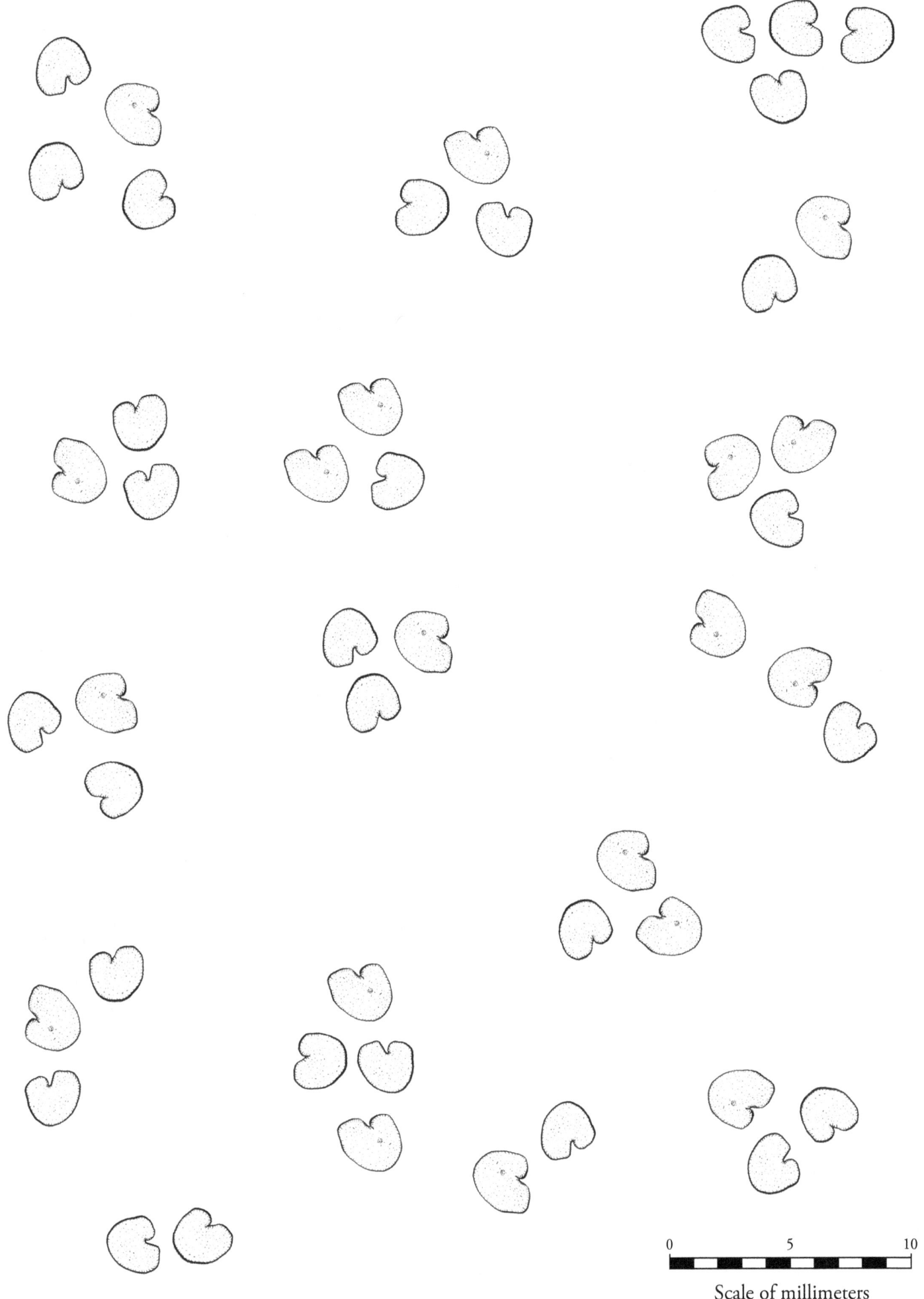

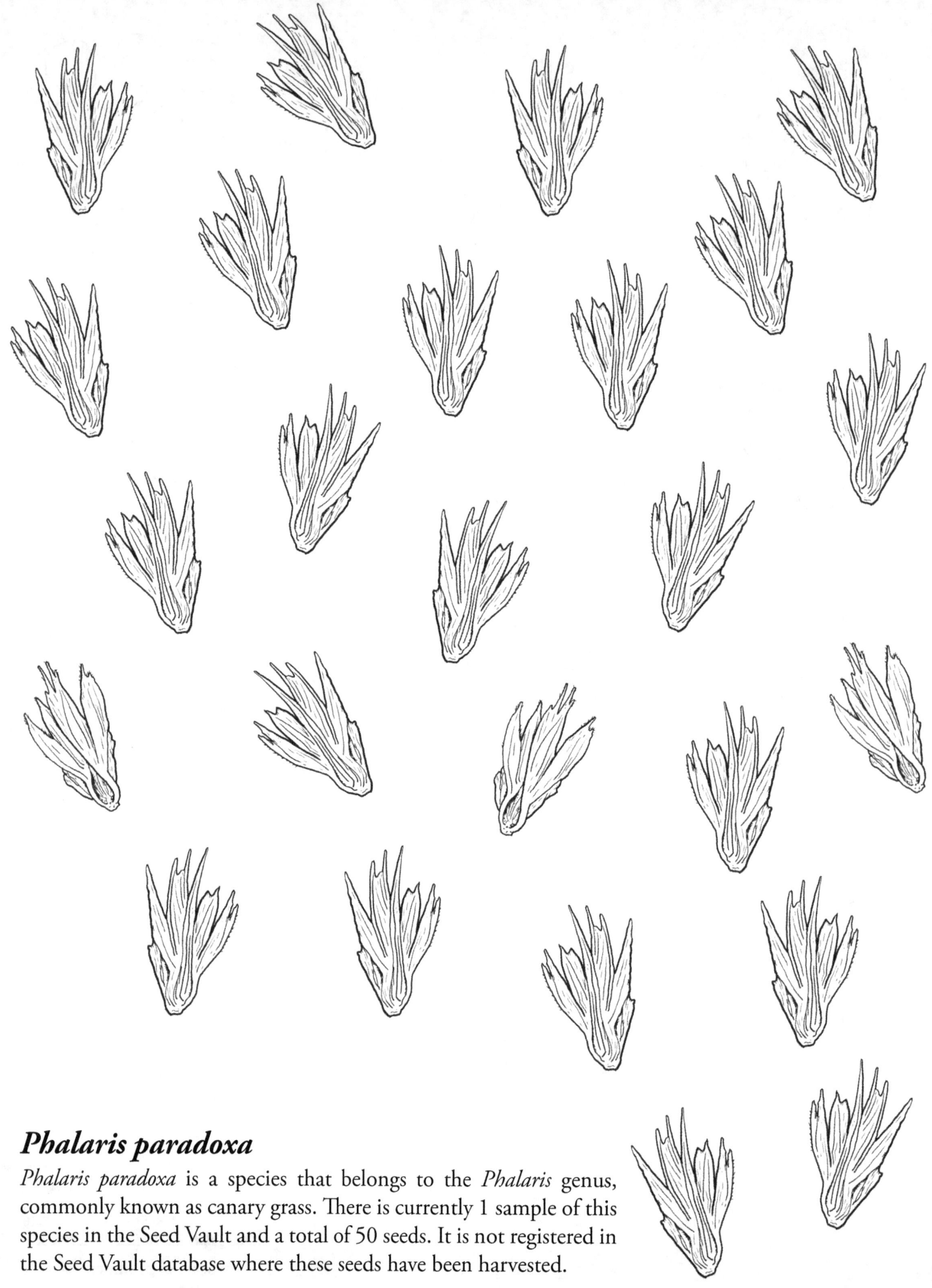

Phalaris paradoxa

Phalaris paradoxa is a species that belongs to the *Phalaris* genus, commonly known as canary grass. There is currently 1 sample of this species in the Seed Vault and a total of 50 seeds. It is not registered in the Seed Vault database where these seeds have been harvested.

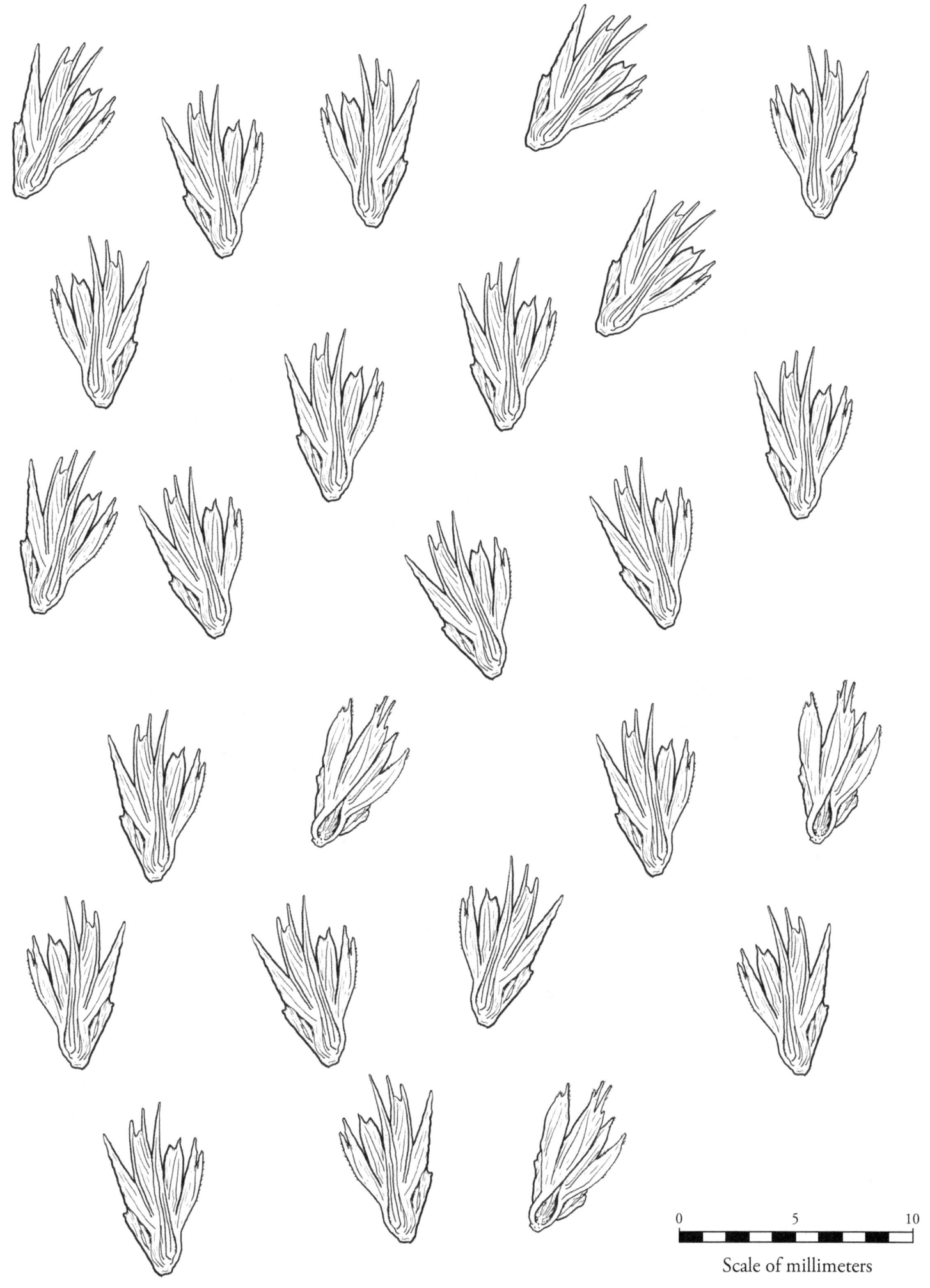

Scale of millimeters

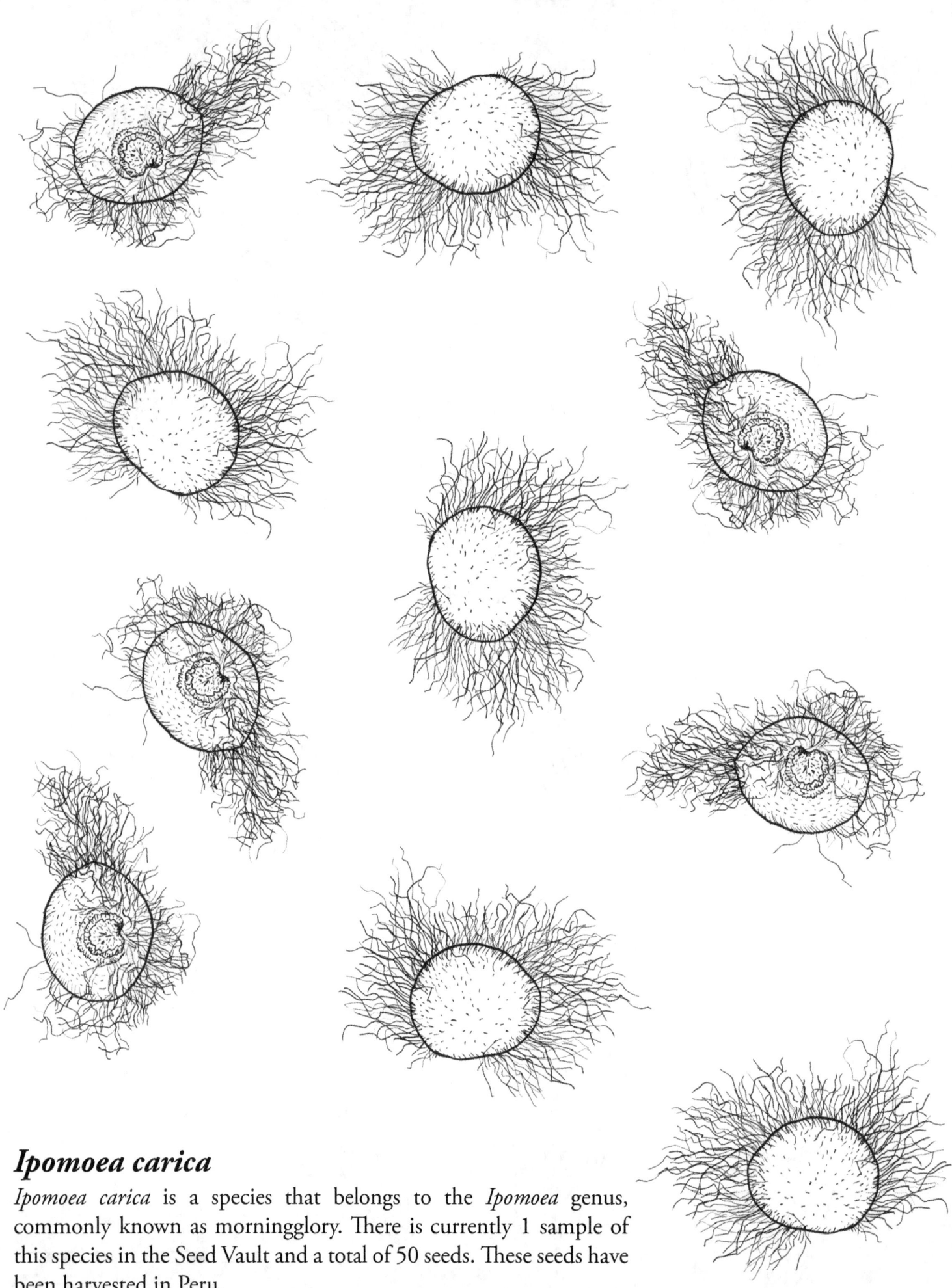

Ipomoea carica

Ipomoea carica is a species that belongs to the *Ipomoea* genus, commonly known as morningglory. There is currently 1 sample of this species in the Seed Vault and a total of 50 seeds. These seeds have been harvested in Peru.

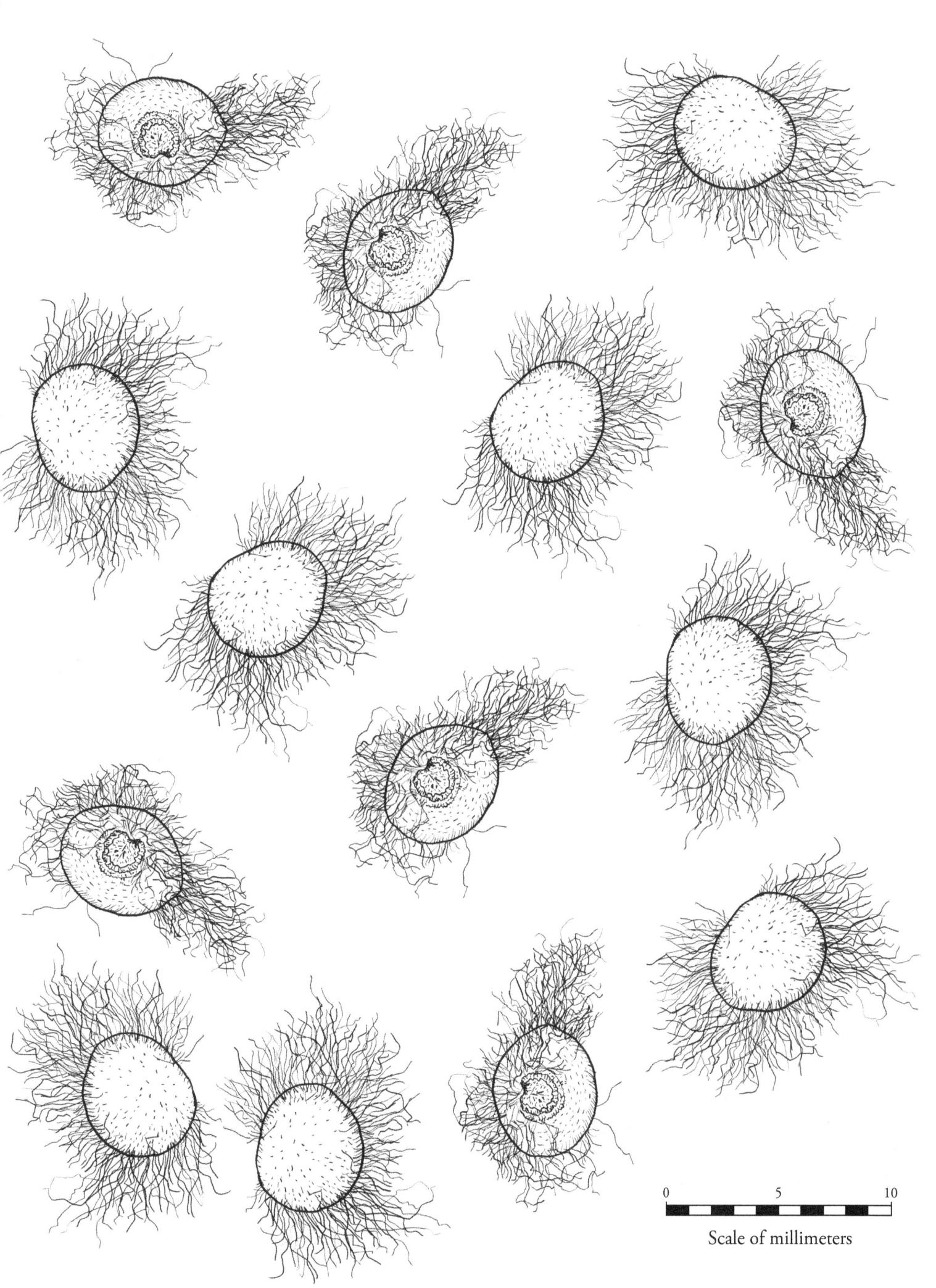

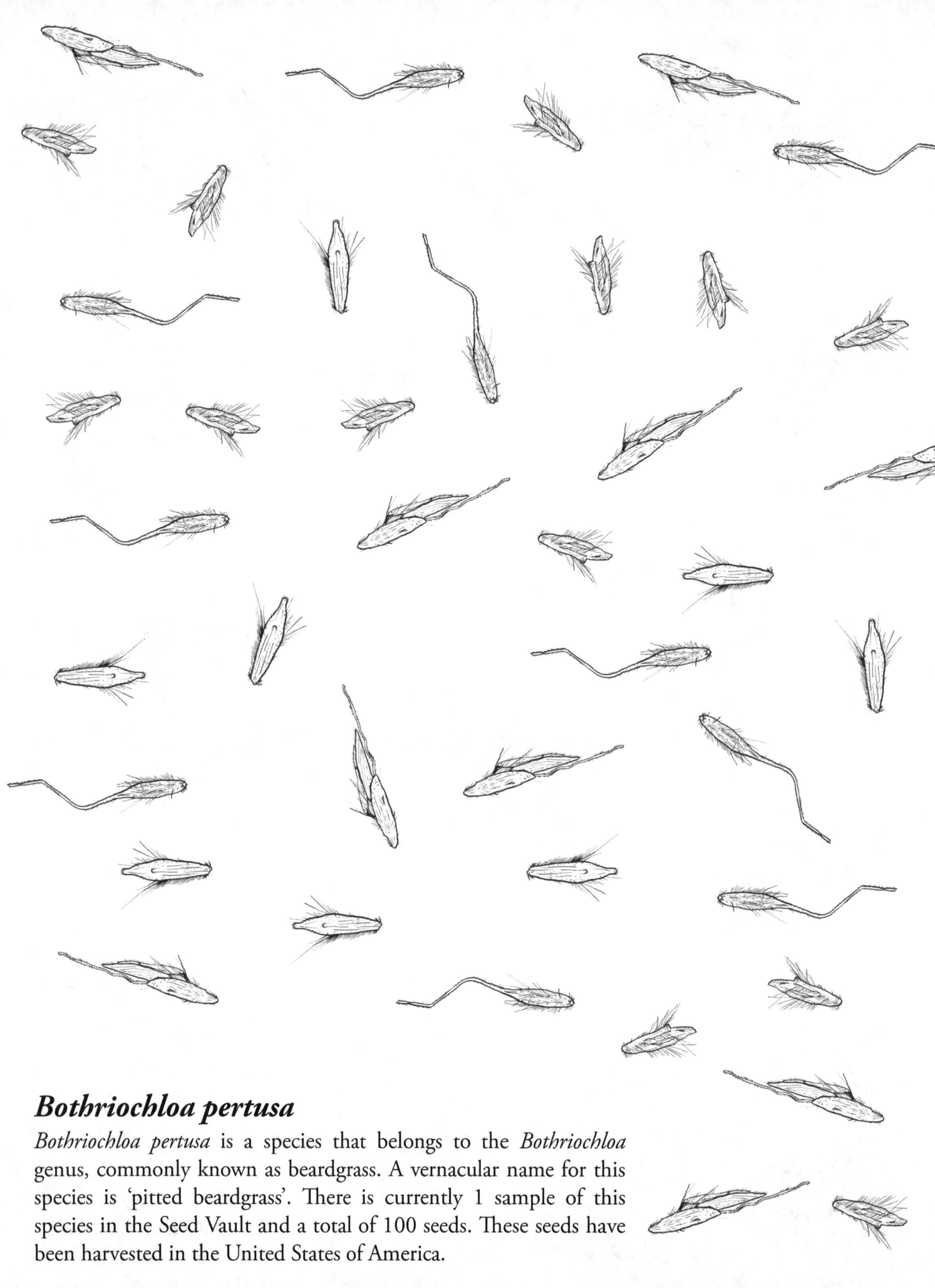

Bothriochloa pertusa

Bothriochloa pertusa is a species that belongs to the *Bothriochloa* genus, commonly known as beardgrass. A vernacular name for this species is 'pitted beardgrass'. There is currently 1 sample of this species in the Seed Vault and a total of 100 seeds. These seeds have been harvested in the United States of America.

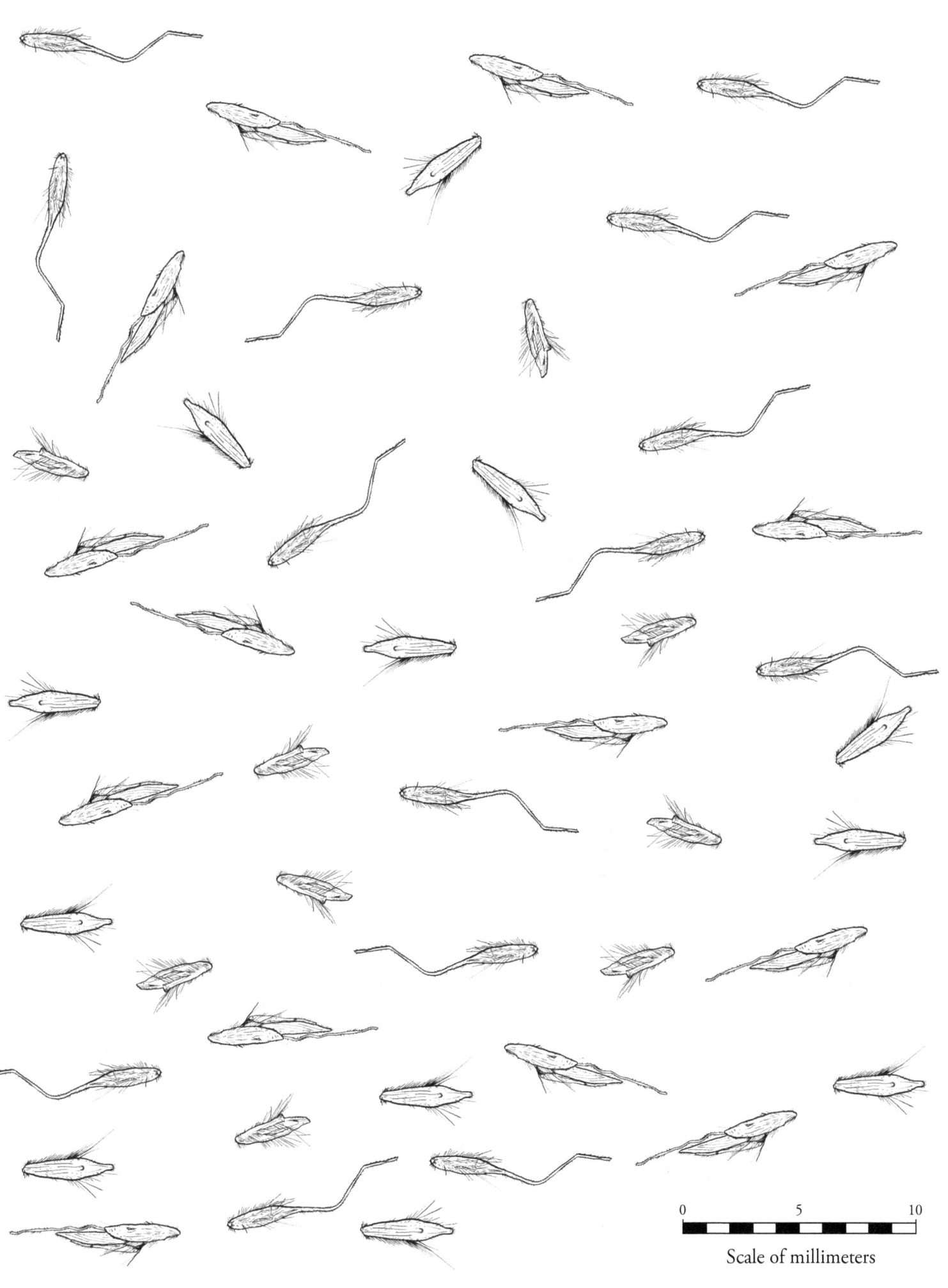

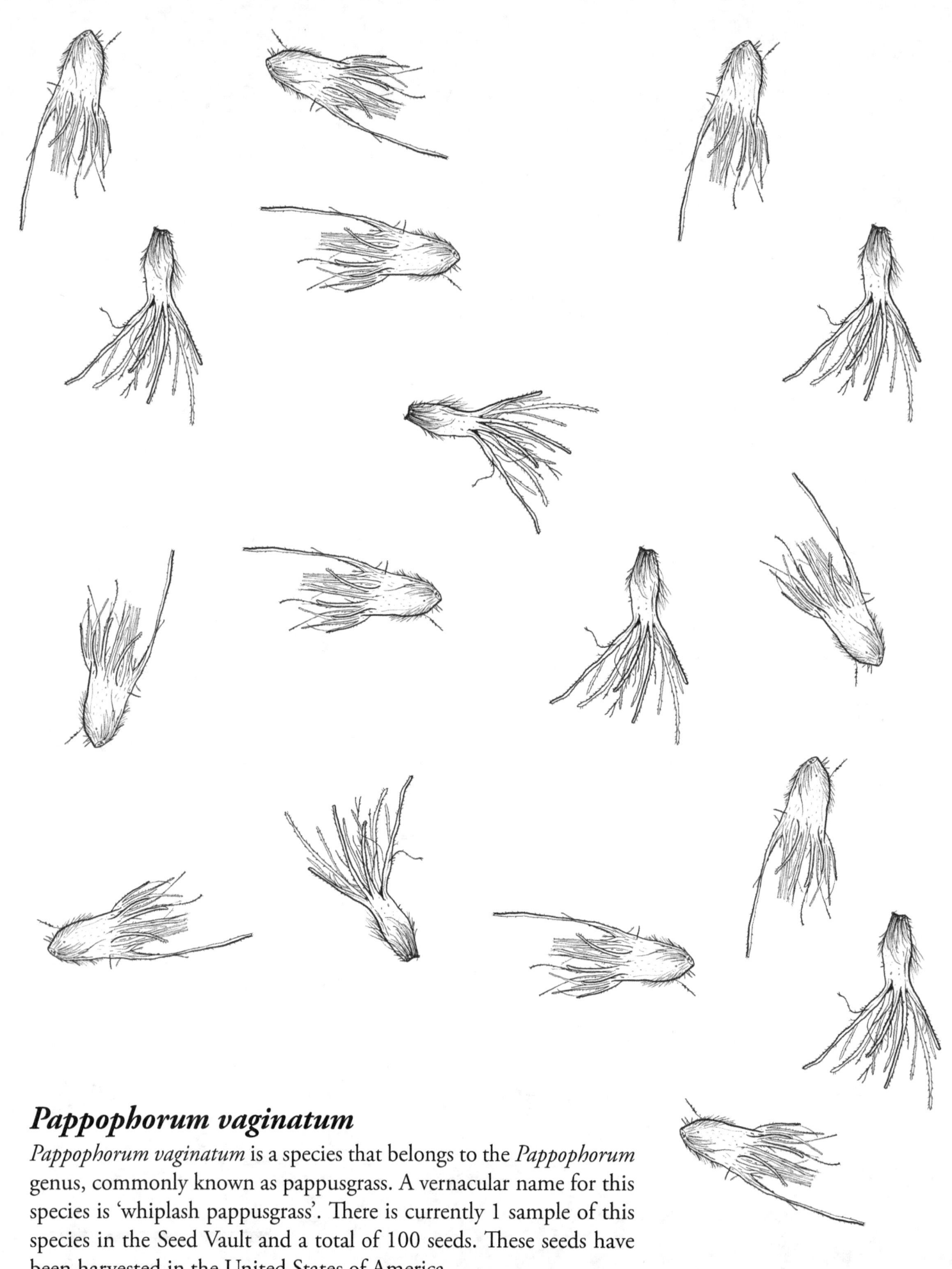

Pappophorum vaginatum

Pappophorum vaginatum is a species that belongs to the *Pappophorum* genus, commonly known as pappusgrass. A vernacular name for this species is 'whiplash pappusgrass'. There is currently 1 sample of this species in the Seed Vault and a total of 100 seeds. These seeds have been harvested in the United States of America.

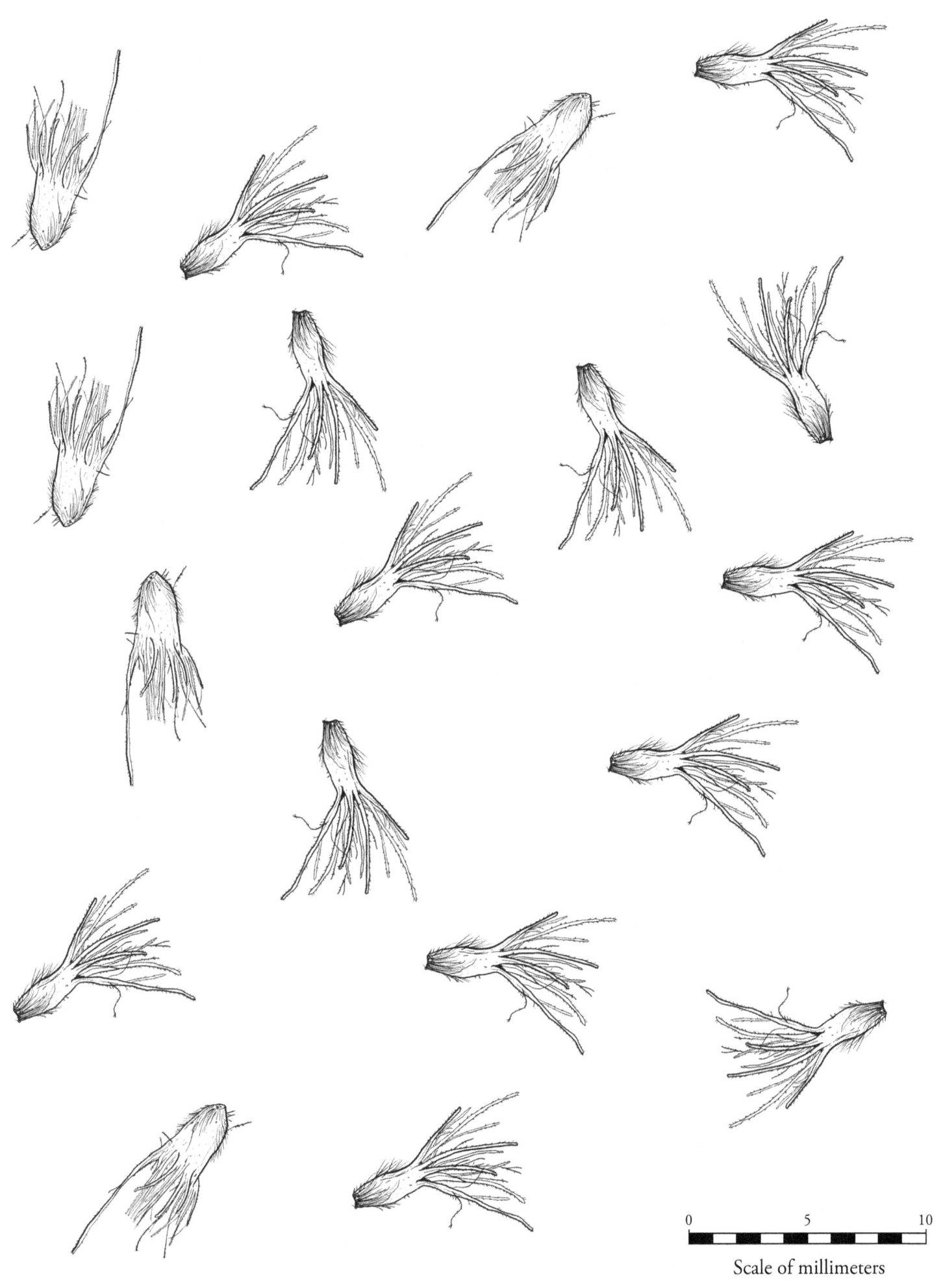

Scale of millimeters

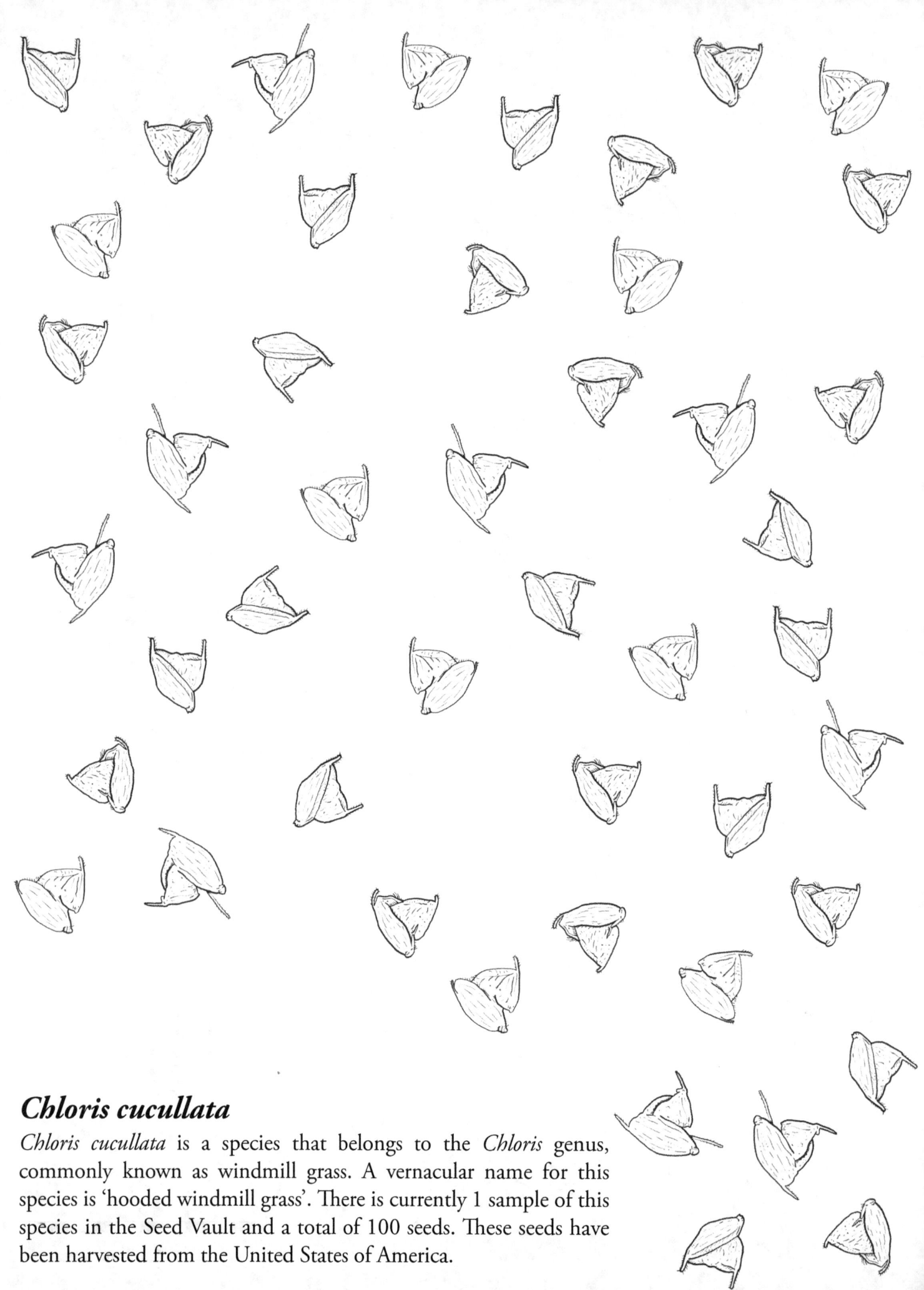

Chloris cucullata

Chloris cucullata is a species that belongs to the *Chloris* genus, commonly known as windmill grass. A vernacular name for this species is 'hooded windmill grass'. There is currently 1 sample of this species in the Seed Vault and a total of 100 seeds. These seeds have been harvested from the United States of America.

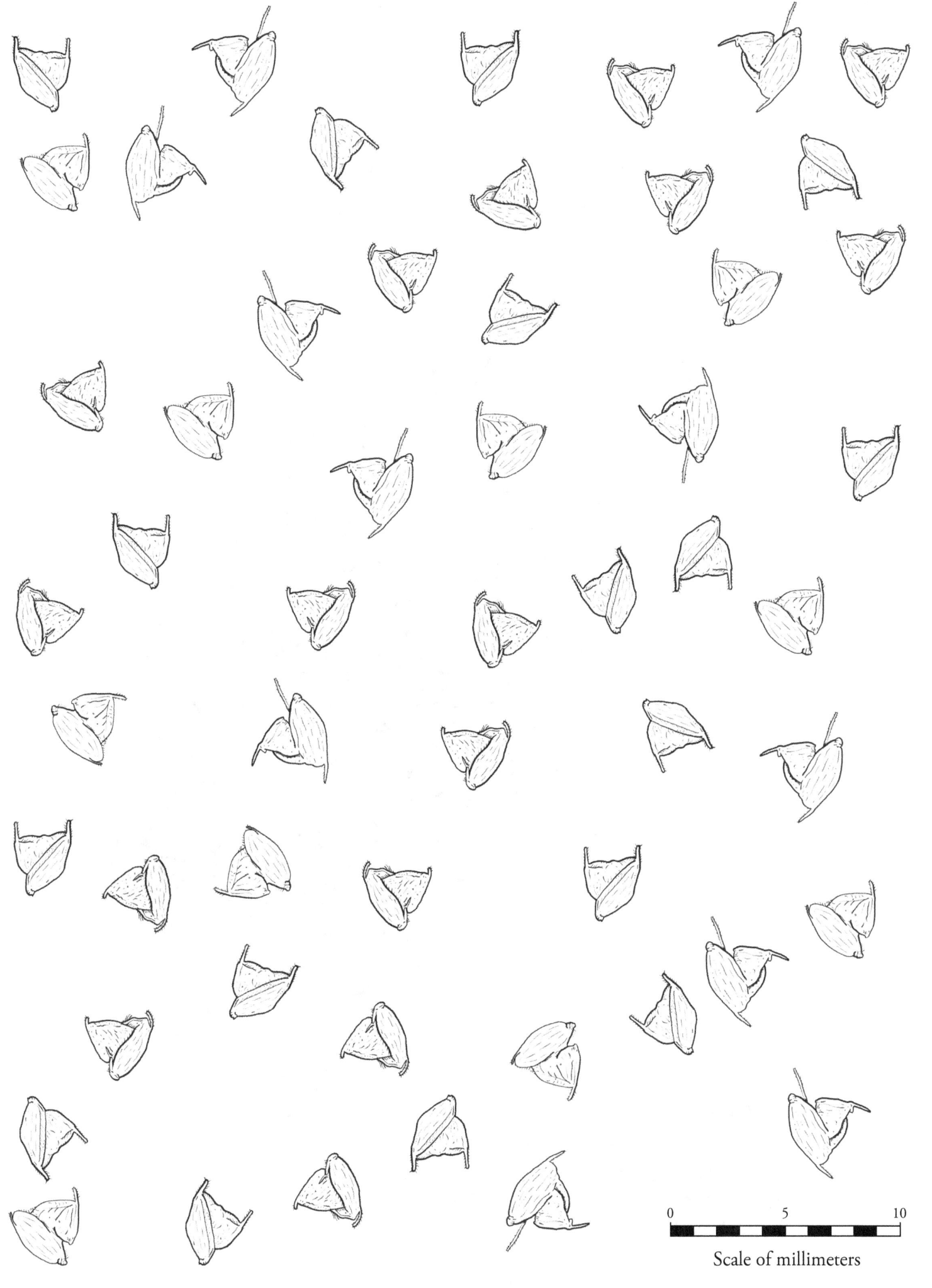

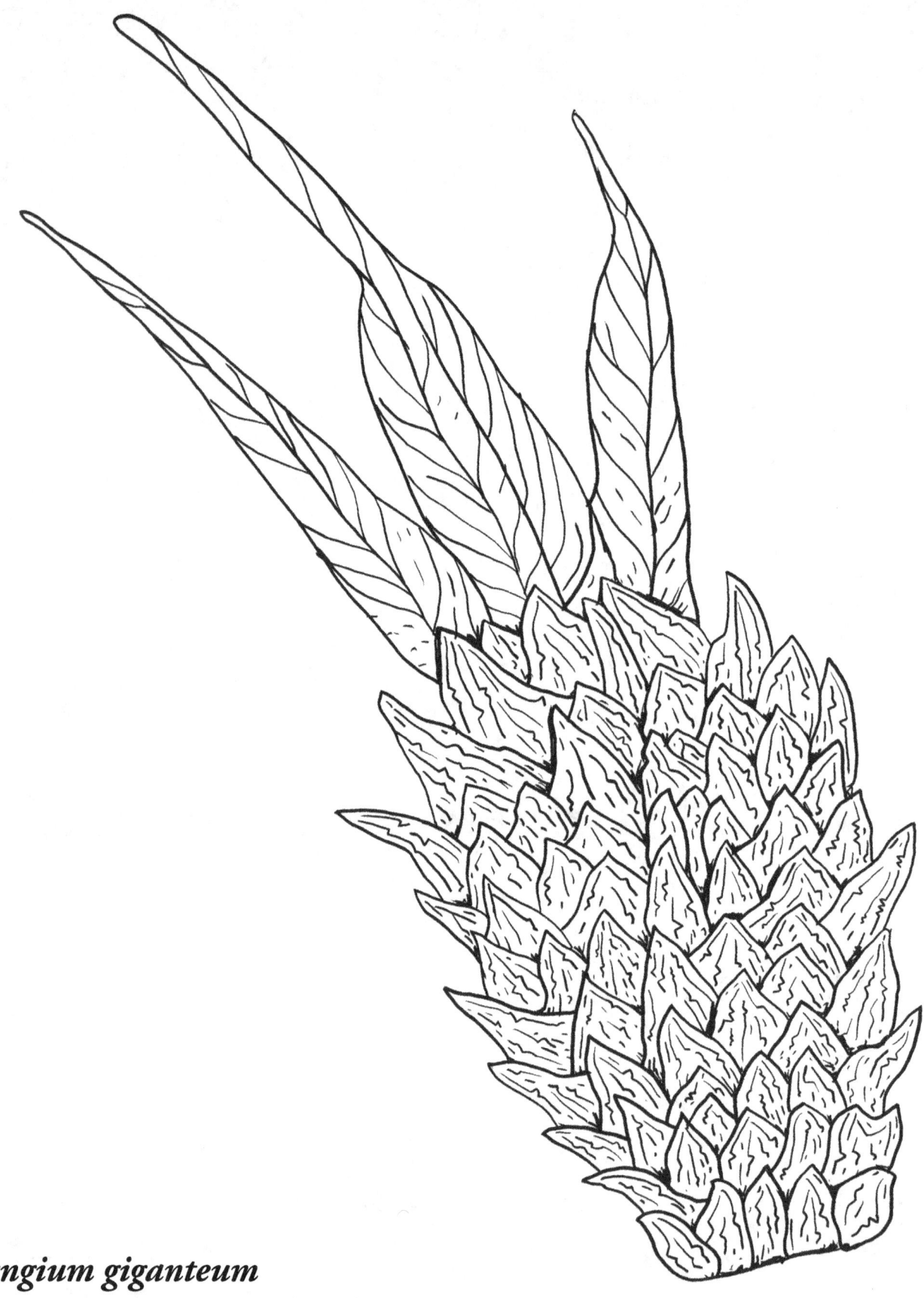

Eryngium giganteum

Eryngium giganteum is a species that belongs to the *Eryngium* genus, common names include eryngo and sea holly. There is currently 1 sample of this species in the Seed Vault and a total of 2 seeds. It is not registered in the Seed Vault database where these seeds have been harvested.

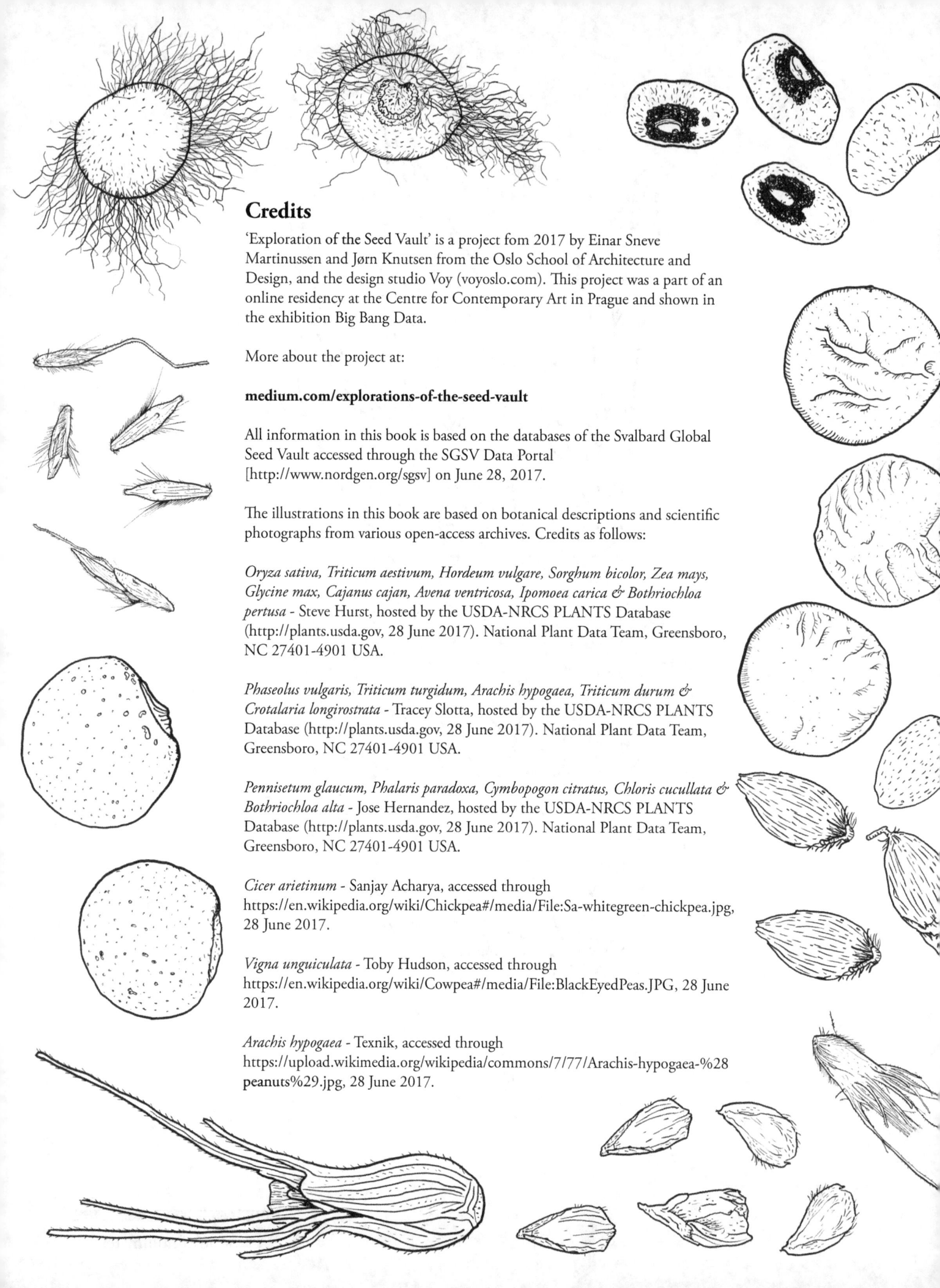

Credits

'Exploration of the Seed Vault' is a project fom 2017 by Einar Sneve Martinussen and Jørn Knutsen from the Oslo School of Architecture and Design, and the design studio Voy (voyoslo.com). This project was a part of an online residency at the Centre for Contemporary Art in Prague and shown in the exhibition Big Bang Data.

More about the project at:

medium.com/explorations-of-the-seed-vault

All information in this book is based on the databases of the Svalbard Global Seed Vault accessed through the SGSV Data Portal [http://www.nordgen.org/sgsv] on June 28, 2017.

The illustrations in this book are based on botanical descriptions and scientific photographs from various open-access archives. Credits as follows:

Oryza sativa, Triticum aestivum, Hordeum vulgare, Sorghum bicolor, Zea mays, Glycine max, Cajanus cajan, Avena ventricosa, Ipomoea carica & Bothriochloa pertusa - Steve Hurst, hosted by the USDA-NRCS PLANTS Database (http://plants.usda.gov, 28 June 2017). National Plant Data Team, Greensboro, NC 27401-4901 USA.

Phaseolus vulgaris, Triticum turgidum, Arachis hypogaea, Triticum durum & Crotalaria longirostrata - Tracey Slotta, hosted by the USDA-NRCS PLANTS Database (http://plants.usda.gov, 28 June 2017). National Plant Data Team, Greensboro, NC 27401-4901 USA.

Pennisetum glaucum, Phalaris paradoxa, Cymbopogon citratus, Chloris cucullata & Bothriochloa alta - Jose Hernandez, hosted by the USDA-NRCS PLANTS Database (http://plants.usda.gov, 28 June 2017). National Plant Data Team, Greensboro, NC 27401-4901 USA.

Cicer arietinum - Sanjay Acharya, accessed through https://en.wikipedia.org/wiki/Chickpea#/media/File:Sa-whitegreen-chickpea.jpg, 28 June 2017.

Vigna unguiculata - Toby Hudson, accessed through https://en.wikipedia.org/wiki/Cowpea#/media/File:BlackEyedPeas.JPG, 28 June 2017.

Arachis hypogaea - Texnik, accessed through https://upload.wikimedia.org/wikipedia/commons/7/77/Arachis-hypogaea-%28 peanuts%29.jpg, 28 June 2017.

www.ingramcontent.com/pod-product-compliance
Lightning Source LLC
Chambersburg PA
CBHW080848170526
45158CB00009B/2672